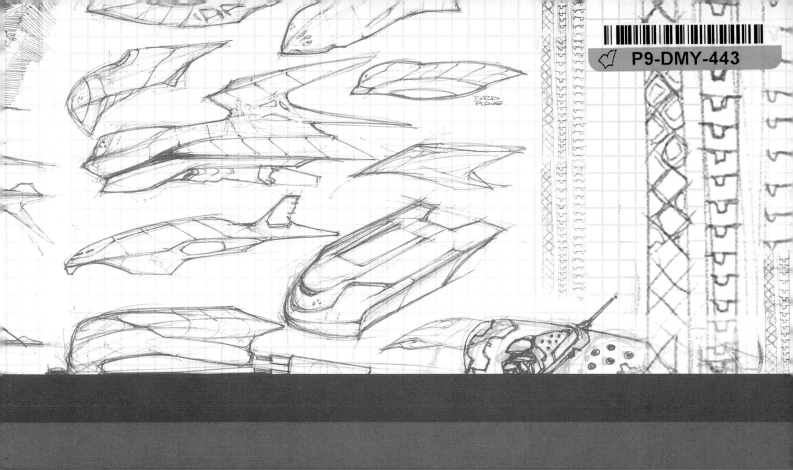

50 FANTASY VEHICLES
TO DRAW AND PAINT

CREATE AWE-INSPIRING CRAFTS FOR COMICS, COMPUTER GAMES, AND GRAPHIC NOVELS

KEITH THOMPSON

BARRON'S

A QUARTO BOOK

All inquiries should be addressed to:
Barron's Educational Series, Inc.
250 Wireless Boulevard
Hauppauge, NY 11788
http://www.barronseduc.com

ISBN-13 (Barron's): 978-0-7641-3522-4
ISBN-10 (Barron's): 0-7641-3522-8

Library of Congress Control Number: 2006923091

QUAR.FVD

Conceived, designed, and produced by
Quarto Publishing plc
The Old Brewery
6 Blundell Street
London N7 9BH

Editors: Susie May, Karen Koll
Art Editor: Claire Van Rhyn
Assistant Art Director: Penny Cobb
Copy Editors: Claire Waite Brown, Richard Emerson
Proofreader: Sue Viccars
Indexer: Diana LeCore
Designer: James Laurence
Picture Researcher: Claudia Tate

Art Director: Moira Clinch
Publisher: Paul Carslake

Manufactured by Modern Age Repro House Ltd., Hong Kong
Printed by Star Standard Industries (PTE) Ltd., Singapore

9 8 7 6 5 4 3 2 1

50 FANTASY VEHICLES
TO DRAW AND PAINT

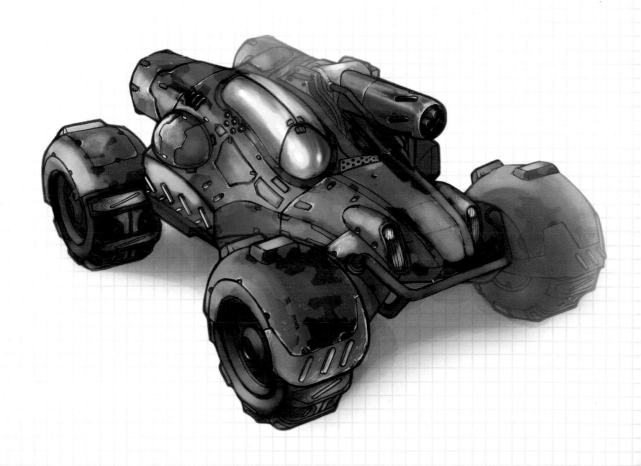

CONTENTS

When you create fantasy art, you invent a unique world stretching far beyond the image itself. You forge individuals, landscapes, societies, technologies—including transportation. How does your knight get to the castle? How do your soldiers reach the citadel? This book lets beginners and experienced artists alike create their own amazing machines.

It is packed with step-by-step advice, tips, and techniques. These are the "glue" that binds together the most complex ideas. More than that, the book is a huge source of inspiration. The craft depicted here were created by different artists, each with his or her own techniques, tastes, and imagination. They offer a rich tapestry of styles to get you started producing your own fantasy designs.

—Keith Thompson

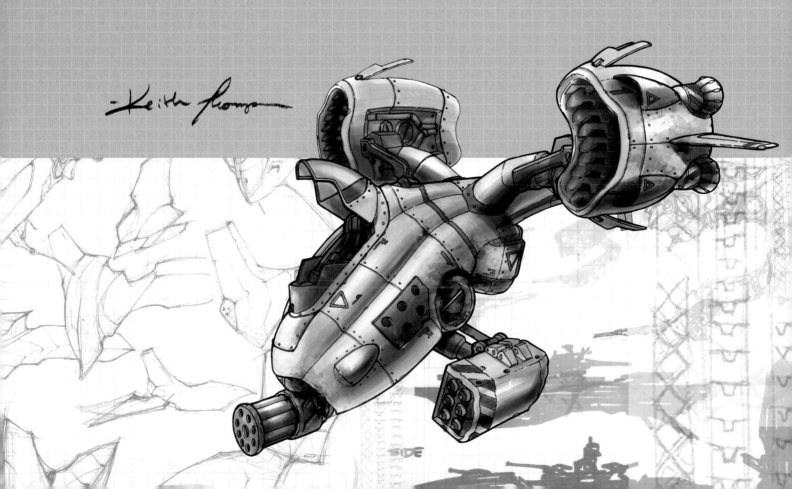

ABOUT THIS BOOK

This book is arranged in sections that will take you through all the stages of producing fantasy art, from initial concept to finishing touches.

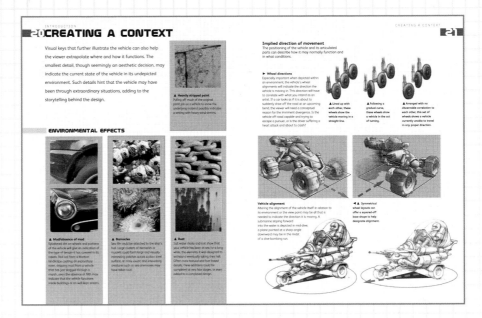

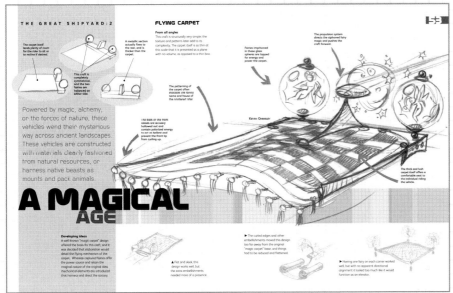

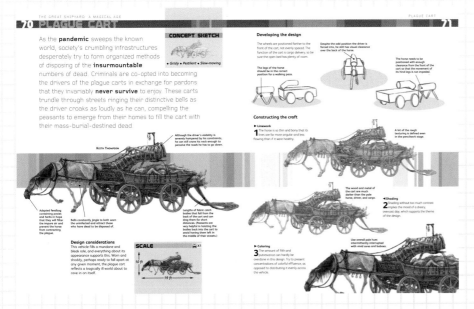

▲ Introduction

This section explains how to develop and construct the basic concept. It gives an overview of the materials you can use, along with advice on the challenges that apply to the design of the craft, depending on, for example, its environment and method of locomotion.

◄ Sketchpads

The introductions to the Great Shipyard sections feature designs "in the rough." These raw developmental steps are the early stages that artists must work through to "flesh out" their creations, often before they even have a clear picture of their ultimate design goal in mind.

◄ The Great Shipyard

Here are scores of fantasy vehicles for you to study and explore for inspiration. This section looks at the techniques used to achieve these amazing results and explains the thought processes behind each basic concept, showing how the artist developed the story through the imagery.

8 GETTING INSPIRED

No artist works in a vacuum. You need good reference sources to inspire your very best ideas. So how do you select your artistic influences? Check out these suggestions for some ideas on where to turn.

Choosing references

When seeking inspiration, it is important to be discriminating in your research. Aim to foster an exclusive attitude toward your key sources, choosing examples that set an ever-higher bar to strive for. That said, your picky attitude should not limit the amount of art to which you are exposed. Use reference material for inspiration to vault you into your own unique sphere of thinking, rather than borrow from it directly. And avoid being limited by your sources, simply mimicking a pre-existing vision. Instead, inject as much of your own personality into your work as you can, and don't be shy of artistic self-indulgence!

Top sources

Here are some sources of inspiration for fantasy art ideas. Whatever you're looking for, they'll light the creative spark that fires your imagination, too.

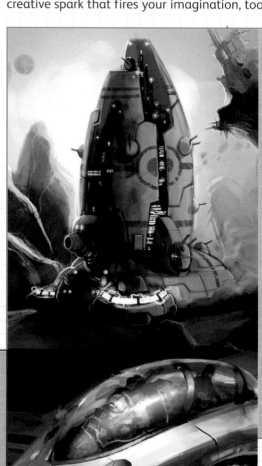

FANTASY ILLUSTRATION

Potentially the most important source of inspiration, fantasy illustration offers an unlimited range of artwork subjects and styles. Study the techniques the artists use to give depth and solidity to their subject, making you feel you could almost reach out and touch it.

FANTASY AND SCIENCE FICTION NOVELS

Books offer a wealth of inspirational ideas and concepts for the fantasy artist to explore. The creative potential of novels is limited only by the author's imagination. Immerse yourself in the world each author creates, and imagine the technology that civilization might produce. Here are a few titles to try:
The Scar by China Mieville
Starfish or Maelstrom by Peter Watts
Dune by Frank Herbert
Starship Troopers by Robert A. Heinlein
Snowcrash by Neal Stephenson

MODEL KITS

A big advantage of kit models of fantasy, contemporary, and historical vehicles is that you can explore them in fine detail. Look at the model from all angles, and place it in different settings for more inspiration. Be sure to study the excellent box-cover illustrations, too!

MANGA AND GRAPHIC NOVELS

Graphic novels show all types of vehicles in sequence, usually from multiple angles, and in different states of movement—top speed, cruising, maneuvering, and parked, for example. They even display the craft's interior and may show views from the driver's perspective.

CINEMA

Movies show multiple views of vehicles in motion, usually to an extremely high level of detail. Cinematographers also employ innovative film and lighting techniques, unusual camera angles, and other special effects that you can adapt for your own vehicle designs.

COMPUTER GAMES

Games on your PC display excellent vehicle designs—and they can be viewed in the round. You can even jump in and take the craft for a ride. When you're finished getting inspired, blow them up or ram them into a wall!

10 STORYTELLING

A vehicle is not just an artistic concept. It's also a practical device; its job is to carry occupants on a voyage around their world.

Your fantasy vehicle may be bizarre and outlandish. It may employ alien technology using principles beyond the known laws of physics. It may even harness forces of magic and the supernatural. But within its own internal logic, and that of its civilization, the craft must be feasible as a means of transportation. This is part of the "story" behind the design. There are several important elements that dictate visual aspects of the vehicle and provide core principles that determine why the vehicle looks the way it does: the users, their technology, and the vehicle's purpose, environment, and history.

FACTORS

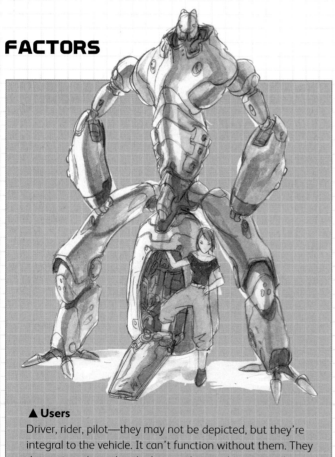

▲ Users

Driver, rider, pilot—they may not be depicted, but they're integral to the vehicle. It can't function without them. They determine why a chair looks as it does, or how controls function. A neglected vehicle implies "outsider." In military craft, family snapshots suggest the occupants are homesick draftees—not hardened mercenaries.

▼ Civilization

As important as the occupants is their civilization. What are its technology, artistic values, welfare concerns, and timeline of existence? You can imply these aspects in tiny details. In a totalitarian regime, for example, a fighter pilot may lack a cushioned seat—indicating little regard for his comfort or health.

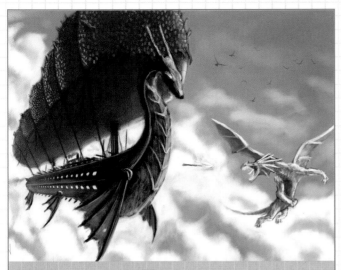

▲ Purpose

Your vehicle's purpose will determine its personality. An angular, spiky profile suggests aggression, whereas sweeping curves imply luxury. You could add an ironic touch, for example, by giving a military craft an oddly understated look, with the merest hint of its true intent—just enough to unsettle the viewer.

▲ Environment

The conditions in which a vehicle functions are reflected in its design. Pleasure craft that run on well-maintained roads might look fragile, gaudy, and pristine. A bathyscaphe plying the ocean depths over geothermal vents will be heavily reinforced, displaying chipped paint and rust stains, all indicating its unceasing battle with the elements.

▼ History

You can imply a vehicle's history and that of the society that spawned it. A piece of resurrected technology, shoddily assembled, with incongruous modern additions, suggests a last-ditch effort by a poverty-stricken nation to resist an invader. A worn-out hulk speaks of a long-lost civilization, pitted against hopeless odds.

USING YOUR EVERYDAY ENVIRONMENT

Defaulting to contemporary influences in fantasy designs can be dull and obvious, but the present is also a direct point of reference. Consider all the factors that contribute to current designs: the pricing of fuel, socioeconomic structures, and cultural influences all heavily shape the way our vehicles appear, and the same should be true in your fantasy settings.

12 PRACTICE AND DEVELOPMENT

You can adapt the same fundamental concept and visual appearance of a fantasy vehicle to serve a wide range of differing roles in your world. In the real world, vehicle manufacturers use a standard motor chassis and adapt it for a wide range of uses: pickup, flatbed truck, sedan, station wagon, or even luxury car. You can apply the same concept to your fantasy vehicles as if produced simultaneously or consecutively by one manufacturer. Your vehicle might be retrofitted, or even transformed, yet still reveal the same basic structure. In the process you open up a wealth of innovative and creative possibilities.

Design cycle
Changes of design can become cyclic, even doubling back on themselves. Moving in circles like this is not a problem, as tiny modifications in earlier designs can be carried over, creating interesting new composites.

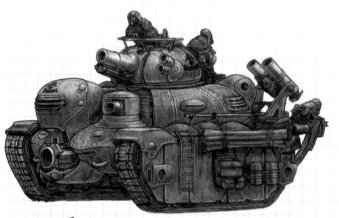

BASIC CRAFT

1 The basic vehicle (in this case a rather conventional tank) acts as the starting point for the development process. You can settle much of the "flavor" of your design at this point, without letting additional concerns muddy your focus.

Elongated

2 This is still fundamentally the same vehicle, but by simply extending its length, I have changed the appearance and "feel" of the craft dramatically. In the process, I have introduced new concerns and fixtures.

Elongated and segmented

3 By stretching the vehicle farther and making it segmented, I've change the design dramatically. It is an armored train and can be extended indefinitely, just by attaching more cars. Confined to tracks, this is now intended for moving freight—very different from the basic military craft.

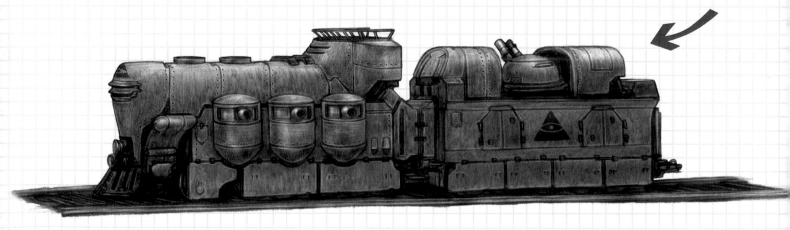

Winged

4 Now I've changed the form of locomotion, and even the medium it travels in. However, I've had to make so many additions so that the craft can take to the air that the basic craft's original frame is almost completely obscured.

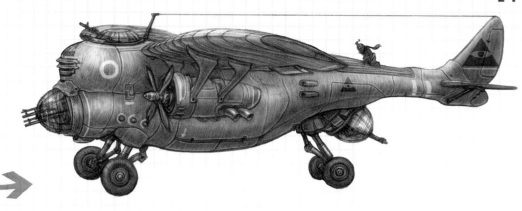

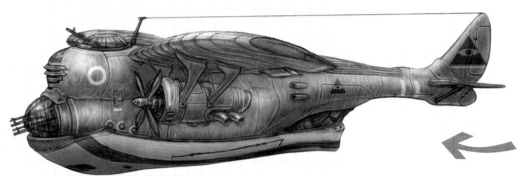

Winged and floating

5 By making a relatively minor alteration—removing the wheels and fixing a hull to the underside—I've added another medium of travel and given it more versatility. This has created a completely different impression.

Floating

6 Now I've removed the wings, a minor modification applied previously, and the shape and function of the craft has shifted once again. The power of flight has been traded for life as a dedicated oceangoing vessel.

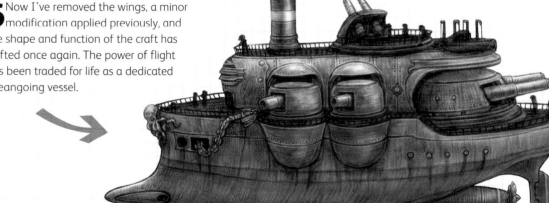

AUTHOR'S TOP THREE EMBELLISHMENTS

Pilot accoutrements
By hanging furry dice from the "towel rack" handles in a fighter, or painting a shark face on the nose cone, you can add a human element to an otherwise cold, factory-made war machine. These touches add extra levels of complexity, both in aesthetic terms and in the storytelling.

Armament
If you arm your vehicle, the viewer can conjure up exciting stories. But don't spoil the logic of the story. A chariot may have blades extending from its axles, but a luxury limo won't have cannons peeking from a sunroof. An understated white phosphorous mister for deterring car-jackers, however, might do nicely.

Patina, or wear and tear
By adding signs of damage or wear, you bring drama and richness to a design. Use it sparingly, though, and in keeping with the story. Covering a moving tank in shrapnel marks and craters makes it hardy and reliable. Decorating a pristine tank in fresh insignia suggests a wealthy, industrial nation.

14 WORKING HABITS

The vital first step is to have a working setup that is comfortable, maintainable, practical, and—above all—conducive to producing fantasy vehicle designs.

 You do not need to micromanage your work space from the start. In fact, it is much better to let it evolve naturally as you begin working. However, there are some key considerations you must take into account. For example, frequent interruptions can break a run of inspiration, or a highly productive spell, so try to ensure enough isolation that you can be free from distractions. At the same time, however, try not to go to the other extreme and create a bare, soulless setting. Otherwise you may begin to resent spending so much of your time in it.

Visual material

You need room to lay out visual sources and other reference materials, including any work with a similar theme that you may be drawing on for inspiration. This not only takes up more space than you might expect but can grow exponentially if you are working on multiple projects.

Breaking the block

Everyone hits an artistic block occasionally, when work keeps coming out badly. Perhaps you are facing repeated interruptions or feel unclear about your goals. Changing subject matter or even media may help. You can usually overcome these barriers by slogging on to get the "bad art" out of your system. Keep working and producing, no matter how disappointing the result. You will soon get back on track. You may even hit a really productive roll.

ACCESSIBILITY

Be practical regarding your chosen work environment. It may be inspiring to work under the half-light of a solar eclipse, but you will probably have too many "off" days if you begin to rely on it. Try to set aside an area where you can control the working conditions.

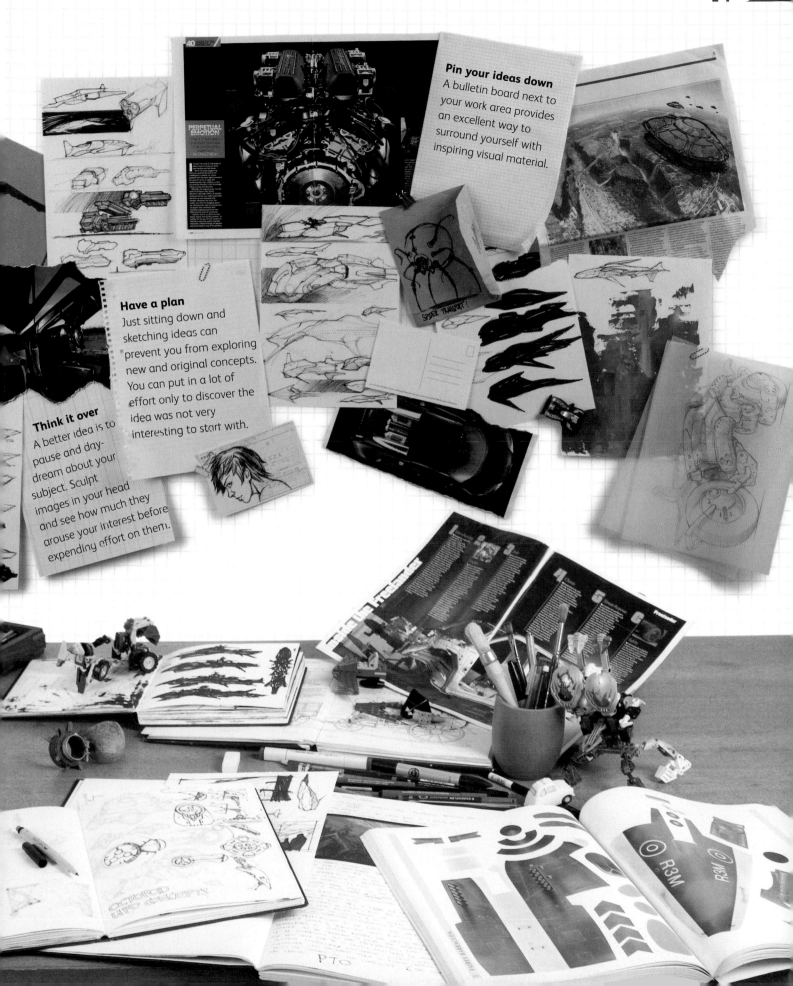

Pin your ideas down
A bulletin board next to your work area provides an excellent way to surround yourself with inspiring visual material.

Have a plan
Just sitting down and sketching ideas can prevent you from exploring new and original concepts. You can put in a lot of effort only to discover the idea was not very interesting to start with.

Think it over
A better idea is to pause and day-dream about your subject. Sculpt images in your head and see how much they arouse your interest before expending effort on them.

16 WORKING TRADITIONALLY

Working traditionally, compared with working digitally, gives the artist an immediate advantage in visual complexity. Every layer you add in a traditional medium compounds the textures and hues in your artwork, and the paper's grain produces a constant and subtle variety to your linework.

TOOLS

Blue Col-Erase pencils *Commonly used by animators, pencils similar to blue Col-Erase pencils are available from several different pencil manufacturers. They're distinct from graphite in that they are far less disposed to smudging and smearing. When scanned, their color can be desaturated and resaturated in whatever hues the artist desires. A wide range of colors are available in Col-Erase, but differing binders and pigments can result in a noticeably varying softness and feel to the pencil. (Experiment, keeping in mind that the actual color is negligible.)*

Pencil extender *Simple pragmatism: with this you can run the pencils down much farther. Avoid using, however, for sweeping, gestural drawing as its balance and ergonomics leave something to be desired.*

Erasers *Try relatively standard white eraser refills for both a normal holder and an electric eraser. Ensure the quality of the eraser before buying, because it can vary widely. Good quality eraser sticks tend to be whiter and softer than their poorer, harder, and yellower counterparts. The regular holder can be useful for immediate and precise erasing, but ensure that the tip is clean to avoid smudging. The electric eraser spins the tip of the eraser and is an extremely fast and efficient way of erasing heavy pencil work, while still being relatively gentle on good quality paper.*

Sharpener *Ensure that electric ones are of the helical variety and not simply a rotating blade. Although certain pencil tips (soft-edged, etc.) are better achieved with a craft knife, a good-quality electric sharpener is extremely useful for general sharpening (and especially batch sharpening).*

Case *A simple pencil case that contains frequently used supplies is handy for taking outdoors for work.*

Masonite board *Experiment with different types of board to find a drawing surface that suits you best. Ensure that it's resilient enough not to bend.*

Paper *116 lb paper is good quality, with a slight texture. Again, experiment with different papers to see if you'd prefer a smoother or rougher texture. Ensure that the paper is heavy and tough enough to handle repeated erasure and drawing.*

Traditional tools vs. digital

Traditional mediums possess an inherent advantage over their digital counterparts in one key aspect: visual complexity. The algorithms involved in imitating a pencil's line on a computer cannot yet come close to presenting the complexity that a real pencil on real paper can produce (eventually this will be overcome). Of course, simply by scanning the image a slight choke point is introduced and some of that complexity may be lost. Certain tasks (such as masking) present absolutely no material advantages in traditional procedures and should be relegated to a solely digital process. A complementary balance should be made between traditional and digital mediums, and they should be recognized not as competitive elements, but as serving differing roles. This balance should shift appropriately to match the desires and needs of the artist; the streamlined efficiency of digital line may actually be far more valuable to artists concerned with smooth work flow and spontaneity, over the immediate aesthetic advantage derived from traditional linework.

▌▌ TRANSITION TO DIGITAL MEDIUM CONCERNS

The steps you make in a traditional medium phase may be intended for scanning where the artwork will be finished digitally.

If the image is too large for your flatbed scanner, you can use a t-square or set square to ensure that each segment scanned is aligned consistently for when you stitch them together in the computer. If you are using a wet medium, ensure it has dried before scanning, lest you muck up your equipment and smear the artwork!

▌▌▌ TECHNIQUES

Line vs. color

Linework

Linework is strictly a drawing, and all of the information conveyed to the viewer is done through stark white to black linear contrast. The line shading, when viewed from afar, creates a uniform value with a slight indication of surface direction.

Color work

The color version of the same vehicle is far tighter in detail and accuracy, and some elements of the design are easier to read. Much of the linework merges and recedes into the design. Completely filled in with value and hue, the vehicle pops out and has now become separated from its white paper background.

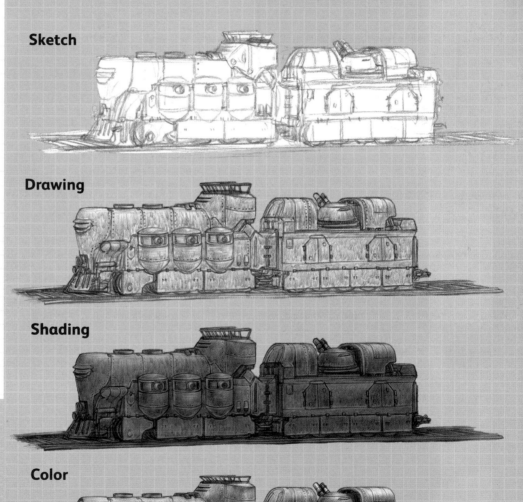

Sketch

Drawing

Shading

Color

Reverse engineer

It may be prudent to key into a style and appearance of art that you would like to come close to before you become too attached to working in a specific medium. Think about how the artist may have executed the art and try to figure out which of the media you already understand could be used to achieve similar effects. Experiment, but do not force yourself to use media you find tedious or unpleasant to work with.

18 WORKING DIGITALLY

The fundamentals of working digitally do not differ in the slightest from working traditionally; however, the computer is such a complex and versatile art medium that it has been separated here into its own section.

Working digitally has the risk of seeming to work in a vacuum. That is to say that you have to be responsible for bringing every single element of your art into your work. There will be no happy accidents, as when a coat of paint bleeds or dries in an attractive fashion, and every visual effect will need to be developed from the bottom up. One of the best ways to compensate for this difficulty is to bring traditional elements into your digital process and to mix the approaches to take advantage of the benefits of both worlds.

TOOLS

Scanner Avoid scanners that are thin or tout speed as a prime feature. Apparently the heavier the scanner, the thicker the plate of glass, which can improve the quality of the scan. Ensure the light is off when not in use because this can wear the bulb and affect the quality. (Bulb-saving features in the scanner's drivers may turn off the scanner, but this can be unreliable. It's a good idea just to unplug the power from the scanner when not in use; this can extend the wait time as the scanner has to warm up when it's turned on, but the increase in longevity is worth it.) Although you may want to scan strange materials for use in art (wood, roughly painted textures, etc.), ensure you don't scratch or mark the glass surface in the scanner.

Tablet There's still a lot to be improved upon in terms of technology in this field, but the tablet is still a completely necessary tool for working digitally. Experiment with tablet sizes, but because a degree of visual disconnection will always be present, a larger tablet might not be worth the ungainly size and the impediment of using the keyboard and mouse in conjunction with the tablet. On multi-monitor setups, ensure that the tablet is designated to only work on the primary monitor, and use a mouse to access secondary displays.

Tablet PC This may be an alternative to a desktop PC or an accompaniment to your main workstation. Although this model has no pressure sensitivity, being able to draw directly on the screen has its advantages (especially for tedious labor, such as masking an image). With a wireless network, one can keep all art files in a shared file on a main computer and access the same file from the laptop with ease. This avoids constant file transfers and attention paid to which computer holds the most recently modified file.

Digital Camera Nothing fancy necessary here; a cheap digital camera is excellent for setting up reference shots. Examples could be: how light may fall in from a window, reference for foreshortening, and perspective reference.

USEFUL TECHNIQUES IN ADOBE PHOTOSHOP

Workspace

You should always slowly develop a workspace that suits your methods. As you work, you will find yourself moving menus around, taking some off and adding others. The less cluttered and more streamlined your work area is the smoother your progress will become, and it will free your mind to focus more on the art itself.

▲ The Layers menu and the toolbar are usually the only things you will want to have open during the whole process. Other menus can be brought up when needed.

◄ Within the Layers menu you should organize your layers in groupings that make sense to you. Being able to find what you need easily, and being able to quickly change layer orders, are important to your work flow.

Dodge/Burn

These specific tools are useful when dealing with value in a gray-scale piece. Use these tools to lighten and darken areas. Hold down Alt key to quickly switch between Dodge and Burn.

▼ Be careful when setting Exposure levels. A lower setting can allow you to make several passes to build up the values you want.

▼ Always make sure your brush size is suitable for the scale you are working at. Use the [and] keys to quickly change brush size.

Selections/Adjustments

Sometimes you'll want to quickly change whole sections of your artwork or even tweak the entire artwork one way or another. Selections can be as precise or general as you wish to use them.

▲ Inversing selections made with the Magic Wand, and modifying these selections, are useful ways to quickly make complex masks to be used when shading or glazing.

▲ Using Image/Adjustments/Levels gives you an excellent visual idea of the values in your artwork and a direct ability to tweak them precisely to what you need.

END RESULTS

A digital process can enable you to attempt widely varying treatments in your design, and it allows you to compare differing approaches side by side. The fundamental design of your vehicle can remain unchanged while you explore several ideas for how best to render the final piece of artwork.

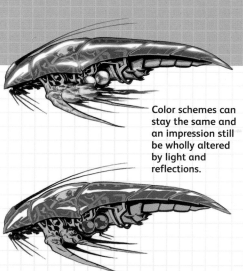

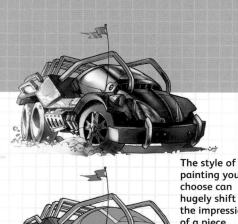

Color schemes can stay the same and an impression still be wholly altered by light and reflections.

The style of painting you choose can hugely shift the impression of a piece.

20 CREATING A CONTEXT

Visual keys that further illustrate the vehicle can also help the viewer extrapolate where and how it functions. The smallest detail, though seemingly an aesthetic decision, may indicate the current state of the vehicle in its undepicted environment. Such details hint that the vehicle may have been through extraordinary situations, adding to the storytelling behind the design.

▲ Heavily stripped paint
Pulling off much of the original paint job on a vehicle to show the underlying material possibly indicates a setting with heavy sand-storms.

ENVIRONMENTAL EFFECTS

▲ Mud/absence of mud
Splattered dirt on wheels and portions of the vehicle will give an indication of the type of terrain it has covered in its travels. Red soil from a Martian landscape coating an exploratory rover, dripping mud from a vehicle that has just slogged through a marsh...even the absence of filth may indicate that the vehicle functions inside buildings or on well-kept streets.

▲ Barnacles
Sea life could be attached to the ship's hull. Large clusters of barnacles or mussels could form large and visually interesting patches across a plain steel surface, or more exotic and interesting creatures such as sea anemones may have taken root.

▲ Rust
Salt water marks and rust show that your vehicle has been at sea for a long while, the elements it was designed to withstand eventually taking their toll. Often more textural and hue based details, these additions could be completed at very late stages, or even added to a completed design.

Implied direction of movement

The positioning of the vehicle and its articulated parts can describe how it may normally function and in what conditions.

► Wheel directions

Especially important when depicted within an environment, the vehicle's wheel alignments will indicate the direction the vehicle is moving in. This direction will have to correlate with what you intend as an artist. If a car looks as if it is about to suddenly drive off the road at an upcoming bend, the viewer will need a conceptual reason for the imminent divergence. Is the vehicle off-road capable and trying to escape a pursuer, or is the driver suffering a heart attack and about to crash?

▲ Lined up with each other, these wheels show the vehicle moving in a straight line.

▲ Following a gradual curve, these wheels show a vehicle in the act of turning.

▲ Arranged with no discernable correlation to each other, this set of wheels shows a vehicle currently unable to travel in any proper direction.

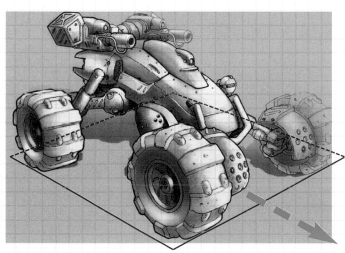 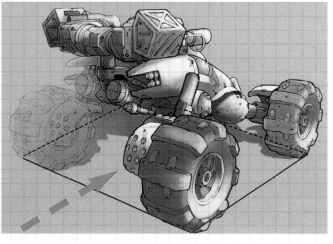

Vehicle alignment

Altering the alignment of the vehicle itself in relation to its environment or the view point may be all that is needed to indicate the direction it is moving. A submarine sloping forward into the water is depicted in mid-dive; a plane pointed at a sharp angle downward may be in the midst of a dive-bombing run.

◄ ▲ Symmetrical wheel layouts can offer a squared-off base shape to help designate alignment.

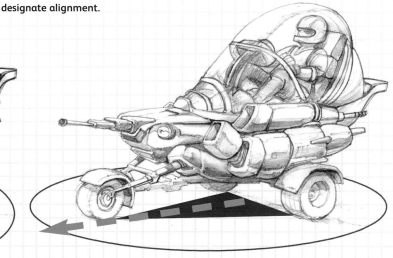

22 SCALE AND PERSPECTIVE

To create the visual illusion of objects being of different sizes and at different distances, you need the two principal tools of three-dimensional art—scale and perspective.

Fantasy vehicles range from massive space stations to tiny sparrows ridden by fairies. Whatever the size, for authenticity both your scale and perspective must be consistent. Objects of similar size look smaller the farther away they're shown. The viewers see this by relating scalable objects to each other. So, although they may not know the size of a particular rock, they can tell if a ladder is wrongly sized for the people standing nearby. Similarly, the viewers might not notice that a nearby figure is too small for a vehicle seemingly 20 ft (6 m) away, but they can spot that a distant doorway is out of proportion to the vehicle next to it.

Simply adding an indication of a figure can be a direct reference point for scale.

▼ Major reference marks
The viewer keys in to recognizable points of scale and compares them with other objects in the art. For example, a tank on its own can be any size—remote-control toy or road-crushing titan. But once you place a person in the image the relative scale is defined.

▲ Subtle reference marks
Recognizable parts of a tank act as a size reference in more subtle ways. A set of steps, windows, seats, or handles, for example, are visual cues that suggest how large a person would have to be in order to use them.

A single recognizable object like a doorway can immediately and effectively set the scale for every other element in view.

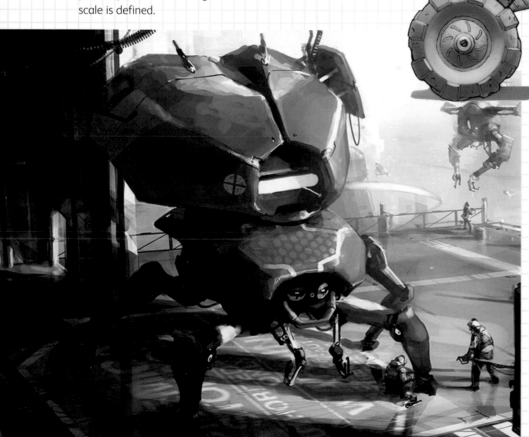

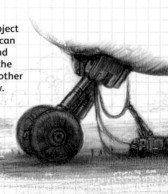

► **Environmental perspective**

Land vehicles keep the same perspective as the surface they are on. If the ground slopes a certain way, so must the vehicle. Allow for a vehicle's implied direction, too. It will look odd if a car seems about to fly off a cliff because of poor alignment with its environment.

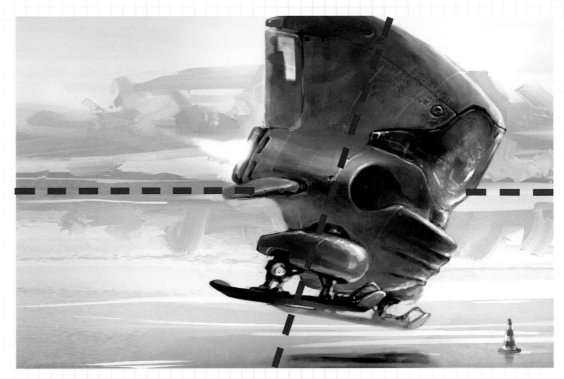

Tilting the craft as it pushes down on its shocks or the cushion of air on which it floats can imply speed and direction.

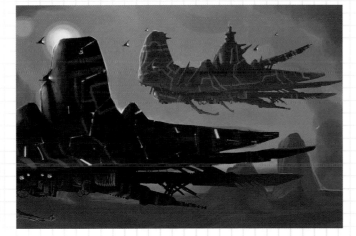

Atmosphere is a key tool for communicating scale, mood, and setting.

◄ **Atmospheric perspective**

Colors tend to become muted with distance. To convey that an object is far away, you can fade it, or change the color temperature (usually cooler) and make it bluer. You can imply massive scale with heavy use of atmospheric perspective, making huge extensions fade off into the distance.

► **Linear perspective**

Vehicles appear to shrink as they move away, and the farthest away of a line of similar-sized craft will also look smaller. Spaces get reduced, too, so that individual vehicles seem to merge. Bear in mind that if distant craft are very big they may still look larger than smaller craft nearby.

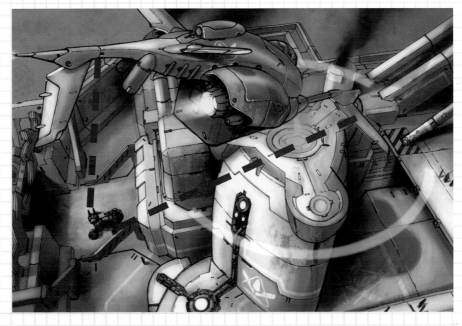

Keep scale in proper relation when working in perspective by imagining a human figure fitting accurately with each craft.

RENDERING MATERIALS

The material from which a vehicle is apparently constructed can affect the overall mood. A wooden galleon is a familiar concept. But one fashioned from bone is eerie and unnerving.

MATERIALS

Wood

This material is extremely versatile and could be used in the oldest, most primitive vehicles all the way up to relatively modern ones. Joinings could show nails, dovetails, or rope binding.

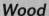

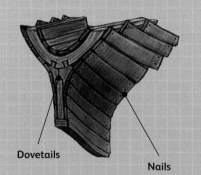

Dovetails

Nails

Stamped Metal

Rivets

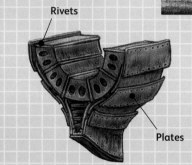

Plates

Apparent methods of joining could be rivets, bolts, or weld lines. A structural strength is implied with this material and, depending on its precision, the level of industry behind the vehicle's construction.

Plastic

Plastics can look different depending on the specific effect desired. Surfaces can be shiny or matte, and the texture can vary due to molding processes. Plastic usually appears almost unnaturally clean or smooth; a good detail to include is a molding seam running along where two pieces have been joined.

Seams

Mold lines

Chitin

Meat

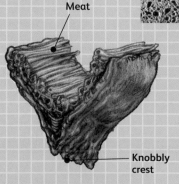

Knobbly crest

Chitin is an organic material with a varying surface texture and structural bumps and protrusions. Because it is being grown by an organism, layers of meat lie on the inside of the shell.

Exotic

Something made from an imagined material must still conform to certain visually logical constraints. If the material and technology are wholly alien and inconceivable, elements of inexplicable weirdness should be included to present an air of underlying structural complexity and believability.

Armature

Shards

Flesh

Muscle

Skin

Follow existing anatomy, or borrow from it. Develop, or at least have a vague understanding of, an underlying bone structure, and lay musculature over this. Create your own riding beasts, twist existing ones, or make an unwholesome meat-based machine.

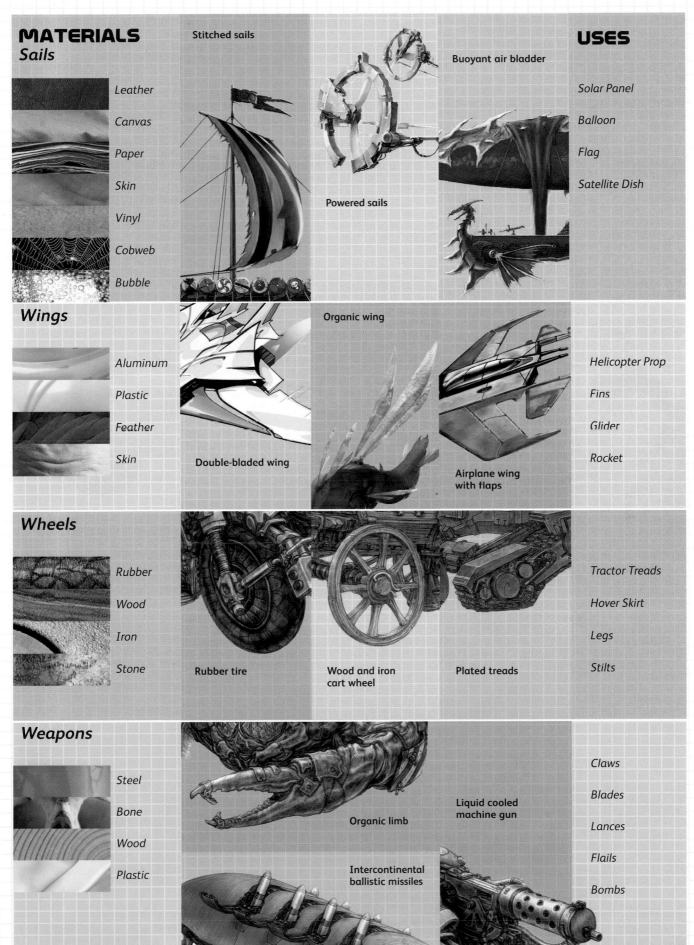

MATERIALS

Sails

Leather

Canvas

Paper

Skin

Vinyl

Cobweb

Bubble

Stitched sails

Buoyant air bladder

Powered sails

USES

Solar Panel

Balloon

Flag

Satellite Dish

Wings

Aluminum

Plastic

Feather

Skin

Double-bladed wing

Organic wing

Airplane wing
with flaps

Helicopter Prop

Fins

Glider

Rocket

Wheels

Rubber

Wood

Iron

Stone

Rubber tire

Wood and iron
cart wheel

Plated treads

Tractor Treads

Hover Skirt

Legs

Stilts

Weapons

Steel

Bone

Wood

Plastic

Organic limb

Liquid cooled
machine gun

Intercontinental
ballistic missiles

Claws

Blades

Lances

Flails

Bombs

26 AIRBORNE CRAFT

Soaring through the sky or swooping down to their destination, there are numerous concerns regarding the design of airborne craft, such as their method of landing or of unloading their occupants.

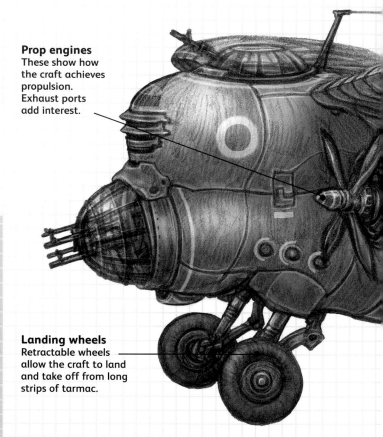

Prop engines
These show how the craft achieves propulsion. Exhaust ports add interest.

Landing wheels
Retractable wheels allow the craft to land and take off from long strips of tarmac.

OCCUPANTS

The occupants' clothes say something about the conditions they operate in. In the aircraft at right, they have comfortable and flashy clothes to wear. A warm scarf, to keep from freezing at high altitudes, shows the craft is unheated. You can use details such as a face mask or pressurized suit to suggest a dangerous atmosphere.

This pilot has an open canopy and needs to wear full face protection with goggles.

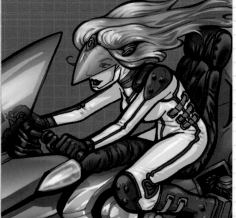

The occupant's ability to pilot a vehicle can be influenced by the comfort of the seating.

PROPULSION

Propulsion is an important consideration in an airborne vehicle; it keeps the craft aloft and propels it along. A dirigible can use low-powered engines, but super-fast or heavy aircraft need motors clearly capable of supplying massive force.

▶ Airports and air shows are great for inspiration, as are aviation magazines.

AIRBORNE CRAFT

27

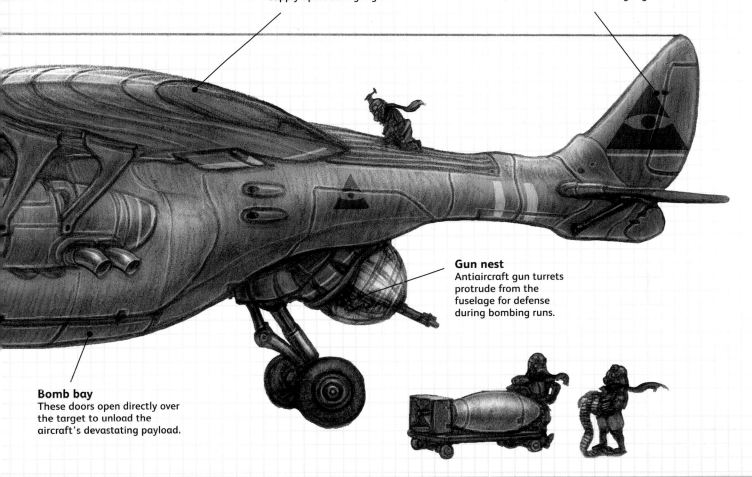

Wings
Curved and aerodynamic, these fixed projections supply uplift during flight.

Tail
This helps stabilize the fixed-wing aircraft during flight.

Gun nest
Antiaircraft gun turrets protrude from the fuselage for defense during bombing runs.

Bomb bay
These doors open directly over the target to unload the aircraft's devastating payload.

LANDING AND UNLOADING

If an aircraft can land give it landing gear, perhaps mixing in elements of known land based craft. If the craft simply hangs in the air then show a method of disgorging its occupants, such as a basket lowered to the ground, or a docking bay connecting with a loading tower.

PROPELLERS

Propellers can either pull the craft, as depicted here, or push the craft forward, as with some dirigibles, early biplanes, and even more modern craft. Make sure they look big enough for the job they must perform.

WINGS

Fixed-wing craft either need some method of propulsion or must function as gliders (requiring a means of launching, such as a winch or powered launch aircraft). If the vehicle is organic, the wings could flap. Indicate how they maneuver—perhaps like bird, bat, or insect wings.

ROTARY BLADES

Helicopters and similar craft use rotating blades for both uplift and propulsion. The main blades alter pitch to travel forward. A tail rotor keeps the vehicle from spinning around with the main rotor, and helps the craft turn.

DIRECTIONAL JETS

In VSTOL (Very Short Take Off and Landing) craft, such as the Harrier fighter, the jets swivel down for ascent and descent, and backward for propulsion. Wings are still needed to maintain lift during horizontal flight.

ROCKETS

This form of propulsion uses a reaction in tanks to produce thrust, which is directed out of a rear port facing away from the direction of travel.

28 WATERBORNE CRAFT

Bobbing atop the waves, or plunging into the ocean's frigid depths, waterborne craft can be developed to serve almost any fantastical purpose the artist can imagine. Traveling across water, though dangerous, lends itself to the creation of vehicles of every shape and size, giving the artist lots of design freedom.

Deck
Should look sturdy enough to support heavy cargo and crew. This one is rimmed by a railing for safety.

Bow
The front, or prow, of the ship, it can be sharp and reinforced as here for ramming other ships.

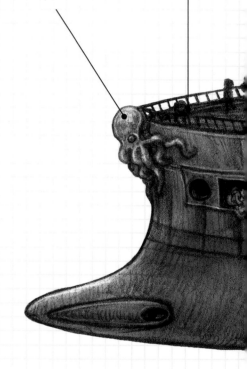

OCCUPANTS

The way the occupants are dressed can say much about conditions on board. At right, the crew members have dressed down to work in the sweltering heat of the engine room below decks. Footwear is light for extra agility needed to carry out tasks on a rolling and pitching deck—or to tread water if thrown overboard.

The life vest is for water safety, but the full suit is to protect agains the intense heat of the fires the pilot will be exposed to.

While the cockpit is fully contained, this pilot wears a full suit for the purpose of leaving the vessel while submerged.

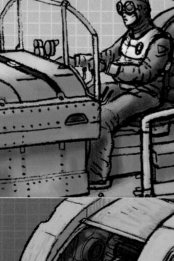

BUOYANCY

How your vehicle floats is a more important concern than its method of propulsion. Even submarines need buoyancy or they will be pulled down to the sea bottom by gravity.

▶ Visit harbors and boatshows for inspiration.

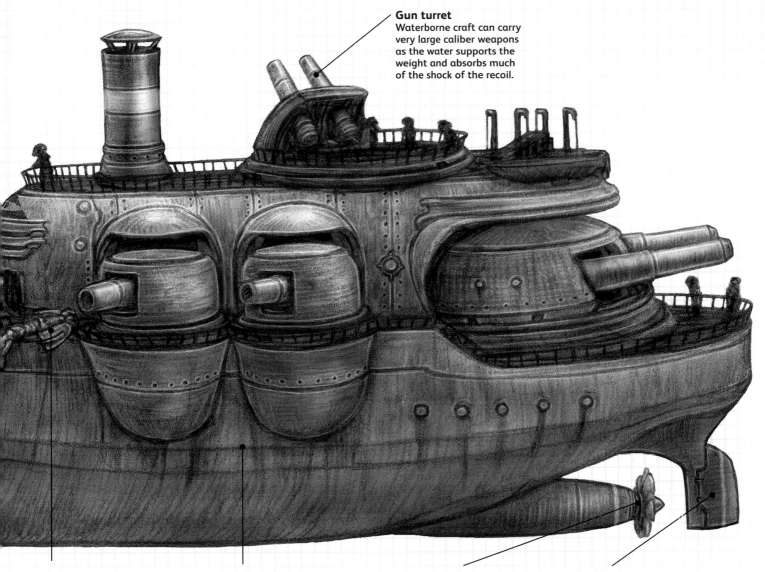

Gun turret
Waterborne craft can carry very large caliber weapons as the water supports the weight and absorbs much of the shock of the recoil.

Anchor
Needs to look big and heavy to prevent the ship from drifting; note the curved hooks that dig into the silt.

Plimsoll line
Hull markings indicate the safe water line—they can suggest a heavily laden, overloaded, or sinking craft.

Propeller
A screw that spins in the water to propel the vehicle and so needs to suggest movement.

Rudder
Located directly behind the propeller, solidly engineered to steer the ship as it turns on its vertical axis.

AIR CUSHION

Hovercraft sit on a cushion of air. The air is drawn down by a propeller to fill a large "skirt" around the base of the vehicle, suspending it above the water.

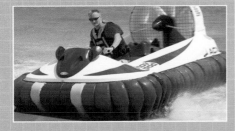

HULL

Can be rounded or angular. The hull should be broad enough to support the ship on the water.

FOIL

Aerodynamic blades project under the hull and act like wings to lift the ship as it gathers speed and skims over the water's surface.

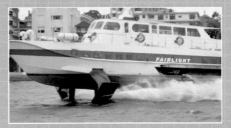

30 LAND CRAFT

Vehicles on land mainly use wheels or tracks and require their own form of propulsion (engines or sails, for example) or are pulled by animals. Before starting on the design, think about its intended role, indicated by its potential speed, armor, or load-carrying capacity, for example.

Turret
This rotates so that the main gun can fire in any direction. One of the entry hatches is on top of this turret.

OCCUPANTS

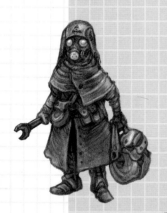

Clothing can suggest more general aspects of the occupants' lifestyle. In the tank at right, they are heavily clothed for spending prolonged periods living outside their vehicle. The clothing looks warm enough to sleep in during cold spells, and appears weathered. Although the crew carry heavy gear for themselves and their vehicle, large items are limited as the inside of the vehicle is probably rather cramped.

This cockpit is comfortable and roomy, giving the occupant a conducive space for complex study work.

A basic rein and saddle setup, while not necessary, could always be incorporated in mounted creature designs.

GROUND CONTACT

How your vehicle maintains contact with the ground is the most fundamental decision to make and will have an impact on every other visual aspect of the design, suggesting time period, speed, power, utility, or brute military force.

▼ Investigate trains and other land craft when you're looking for ideas.

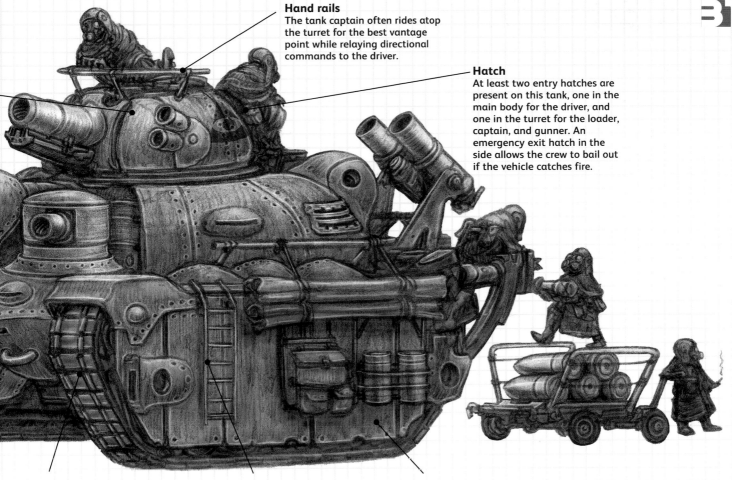

Hand rails
The tank captain often rides atop the turret for the best vantage point while relaying directional commands to the driver.

Hatch
At least two entry hatches are present on this tank, one in the main body for the driver, and one in the turret for the loader, captain, and gunner. An emergency exit hatch in the side allows the crew to bail out if the vehicle catches fire.

Treads
Interconnecting and articulated plates are kept in line with the inner wheels by guide horns, which protrude on the inside of the tracks.

Ladder
Used by crew members to climb up onto the tank.

Tread skirt
An armored set of plates, the tread skirt is designed to protect the vulnerable wheels.

WHEELS

Select a material that indicates the level of technology. Choices include split wooden wheels, wood or metal spokes, metal rims, solid rubber, or inflated tires and shock absorbers. Tread implies function—use smooth, thin wheels for metal roads or thick tread for off-road driving.

HOVER

As with waterborne hovercraft, an inflated cushion and skirt keeps the vehicle off the ground. A method of forward propulsion is also needed, such as propeller or jet engines.

LEGS

The method of conveyance could be a traditional four-legged beast of burden, such as a horse or mule, or something more exotic, such as an ostrich or a caterpillar. Mechanical legs are another option, and their appearance can imply the technology level of the makers.

RAIL LINES

Perhaps the craft can function only on a pre-built rail network. Depending on the technology level, this could be conventional dual rail tracks, monorail, magnetic track, or something more innovative.

TRACKS

Segmented metal tracks run along internal wheels and suggest heavy, industrial, or military vehicles used over rough terrain.

32 THE WHOLE PROCESS

This section gives a detailed walk-through of the process of creating a fantasy vehicle from start to finish. This is just one approach—there are many other ways to go about it.

▌▌ TOOLS AND MATERIALS

This detailed process uses:
Black Col-Erase pencils
160 lb paper
Scanner
Wacom tablet
Adobe Photoshop

LINEWORK

The thumbnail

1 This initial step is often little more than a scribble, but it encapsulates key shapes and details that will be the dominant attributes in the final art. You may have to repeat it several times until you home in on your desired "feel" in a loose concept.

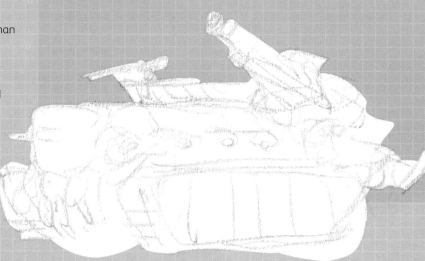

This one is enlarged, but a thumbnail can be quite a bit smaller.

Loose gesture

2 This is the first stage in a process that leads to the actual piece of art. The movement, posture, and proportioning of this stage carries through to the end. Much of the success of the finished piece relies on how well you manage this stage. However, there will be a degree of "wiggle room" as the art progresses.

Elements only hinted at in the thumbnail are now outlined and discernible.

Contour lines

3 This is the raw idea of your vehicle laid down, completely, on paper. It may still be very rough, lacking visual cohesion and focus, and include scuffs and mistakes. But you will finalize the basic design at this stage, developing structural points and deciding if the idea will "flesh out." Draw in all conceptual aspects, as details and characteristics take shape here.

The protruding tracks are angled to bite into the ground.

The tank is totally readable at this point, with all the design elements clear.

Hatched, finished lines

4 After scanning, you can start on the aesthetic modifications in earnest. Lay in focal points, add more linear detailing, and accentuate the contour lines with repeated passes. Knock back or fade off any lines and portions that appear too dominant. Work out linear hiccups and scuffs in order to clean up the drawing.

Hatched linework adds to the shading.

Hatched linework is applied to every surface in varying degrees.

SHADING

Loose shade

5 Imagine the vehicle is made from a single, homogenous material, like a clay sculpture. Patch in overall areas of shade, darken the underside, and lay out major plane shifts. Make a rough selection so that the loose shading doesn't spill out from the vehicle too much, but don't be too fastidious with these concerns. You can clean up at later stages.

The track projections radiate out along the curve of their path.

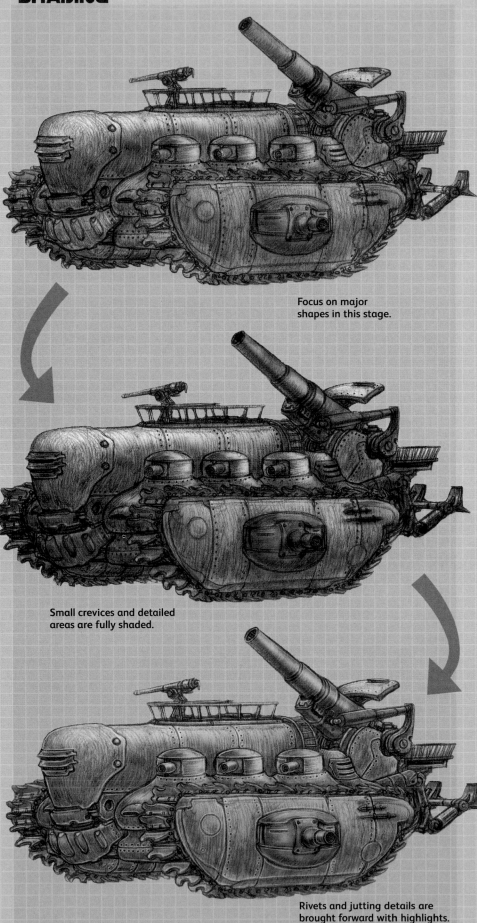

Focus on major shapes in this stage.

Tight shade

6 Areas of dominant darkness and high contrast draw the viewer's eye, so orchestrate these to point to the foci of the artwork. You are producing a visual patchwork. Lay in areas of high contrast and consider differences in material and overall shade.

Deep areas of shadow recede from the viewer's eye.

Small crevices and detailed areas are fully shaded.

Highlighting

7 Now lay in opaque tints of white over the shading. Degrees of contrast can affect the appearance of the artwork dramatically. Bear in mind that transitions between absolute black and white may be too harsh for your desired result.

Sharp white detail can be added later at the coloring stage.

Rivets and jutting details are brought forward with highlights.

COLORING

Canvas ground

8 Here you choose the "canvas" or ground the final artwork is laid upon. In traditional methods this occurs between the thumbnail and loose gesture stages. With a layered process, as here, the hues and texture of the ground show through and dictate the appearance of the finished design. Digitally, you can choose any material you like, though it is best to work with a relatively consistent pattern, without dramatic contrasts in hue or texture.

The canvas's original color gives overall hue.

First glaze coat

9 Here you lay in large patches of hues in the pattern that will dictate the overall color scheme of the finished art, much like a coloring book.

This stage brings the addition of the dominant color of the tank.

Color is applied uniformly and can be removed or glazed over later.

Second glaze coat

10 This is the final coloring stage. Many of the colors you use may get mixed together, merging into the dominant hues you laid out previously.

Different materials are now separated by hue.

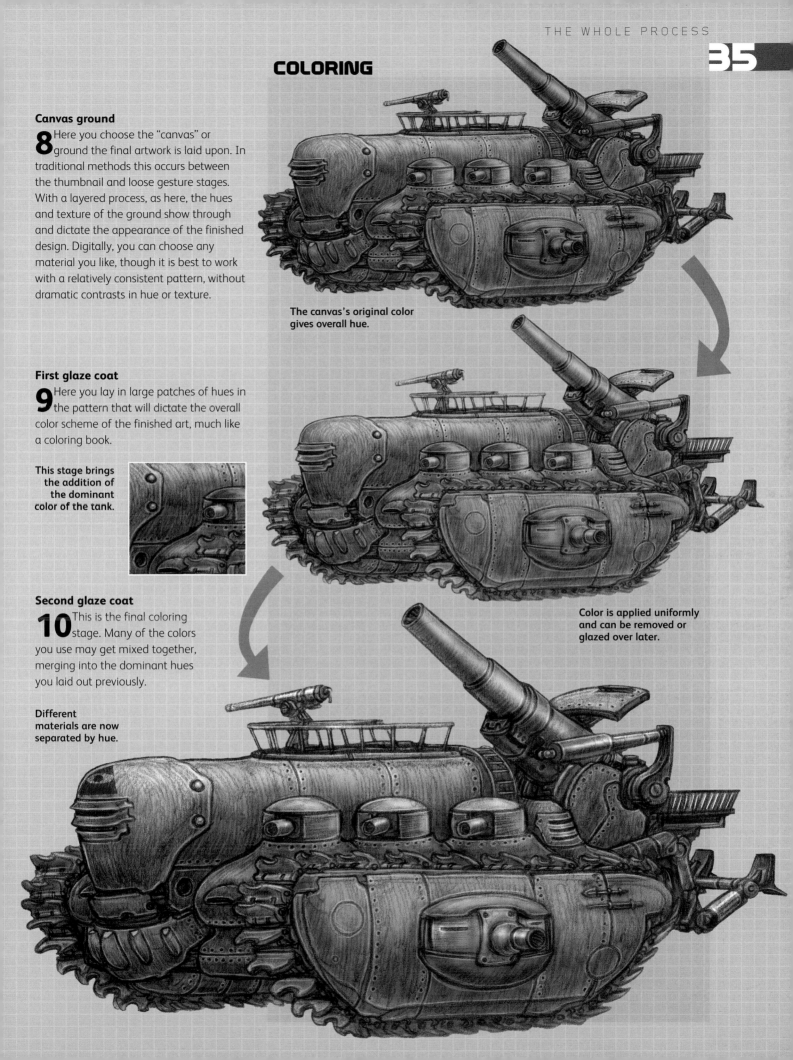

THE GREAT SHIPYARD

This section describes and demonstrates how to draw and paint 50 fantasy vehicles. The text and illustrations guide you through each vehicle's construction, explaining key points. You'll find information about the various craft and step-by-step sequences that show the creative process. Each ship, aircraft, or other form of conveyance is broken into primitive shapes to show its construction, making it easy for you to recreate it yourself. Some basic craft are shown at the beginning of this section. Climb into the cockpit and get started!

The craft is extremely recognizable in this view, and the finished version is not actually very different from this simplified form.

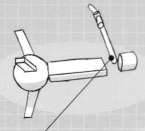

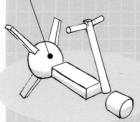

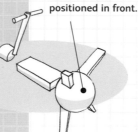

The complex collection of angular joints near the front is left out of the structural drawing.

This view really presents how much of the craft is clustered in the rear with the rider positioned in front.

SKATE-N-SCOOT

From all angles

Simple craft designs lend themselves extremely well to solidifying the craft's three-dimensional form. Depending on how often and in how many views you plan on depicting the craft, its structural complexity may be a major practicality factor for you as an artist.

Structurally simple, and with underlying mechanical functions that are easy to understand, the basic craft provide an excellent introduction to fantasy vehicle art for the beginner artist. If the later vehicles seem too difficult at the moment, ease into them by studying these early examples.

BASIC CRAFT

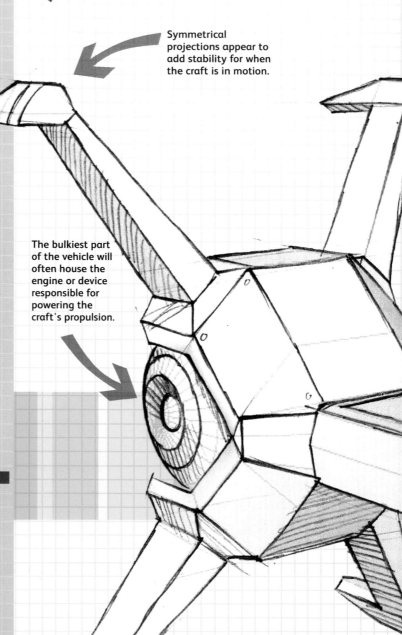

Symmetrical projections appear to add stability for when the craft is in motion.

The bulkiest part of the vehicle will often house the engine or device responsible for powering the craft's propulsion.

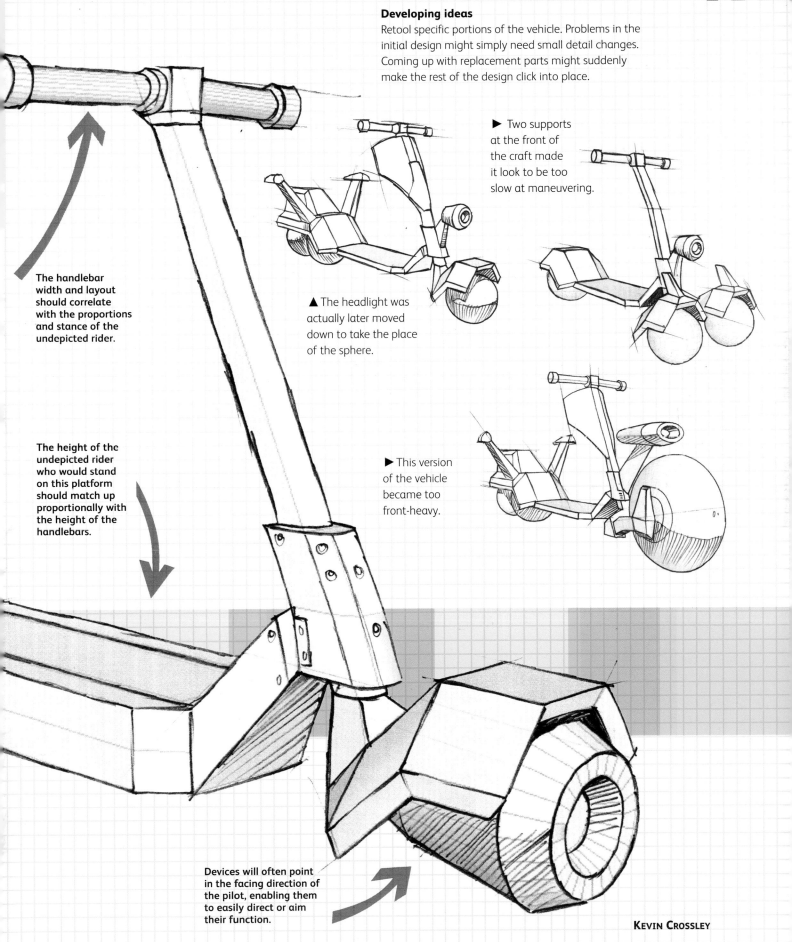

Developing ideas

Retool specific portions of the vehicle. Problems in the initial design might simply need small detail changes. Coming up with replacement parts might suddenly make the rest of the design click into place.

► Two supports at the front of the craft made it look to be too slow at maneuvering.

▲ The headlight was actually later moved down to take the place of the sphere.

► This version of the vehicle became too front-heavy.

The handlebar width and layout should correlate with the proportions and stance of the undepicted rider.

The height of the undepicted rider who would stand on this platform should match up proportionally with the height of the handlebars.

Devices will often point in the facing direction of the pilot, enabling them to easily direct or aim their function.

KEVIN CROSSLEY

40 PERSONAL FLYER

ZIP BIKE

▼ Basic shapes

1 Inspiration for the design came from studying a range of modern motorcycles. Sleek lines give a powerful feeling of forward motion, even when the vehicle is idle.

Side-mounted engines pivot to give optimal maneuverability.

The front portion of the structure is half windshield.

- Compact
- Hovering
- One-person carrier

The bulk of the vehicle's structure is at the rear, and the rider perches forward on this.

◀ Rough line

2 The smooth and sharp curves of the Flyer's frame are carefully and cleanly laid in even at the rough stage. Important details like the pilot's face are well on their way; less important areas such as the handlebars and exhaust are still sketchy.

▶ Outlining

3 Use three different sizes of artist ink pens to finalize the linework. Use .01 mm for fine internal lines, .03 mm for thicker outer lines, and 1.0 mm to fill in larger areas of black.

▼ Rendering

4 Use bright and intense colors to indicate the personality of the pilot, who wants to go really fast and make a big impression with spectators.

Details such as the hair blowing back enhance the illusion of motion.

Motion lines added to the taillights give extra flair.

Long reflections in the windshield suggest lights speeding past the vehicle.

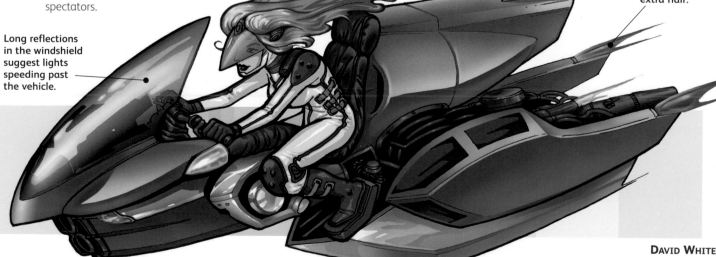

DAVID WHITE

FLYING INCINERATOR

TRASH TRANSFORMER

► Basic shapes

1 In a world where land is desperately scarce, the Flying Incinerator collects dust and industrial wastes, transports them to a special zone, and burns them, collecting energy in the process.

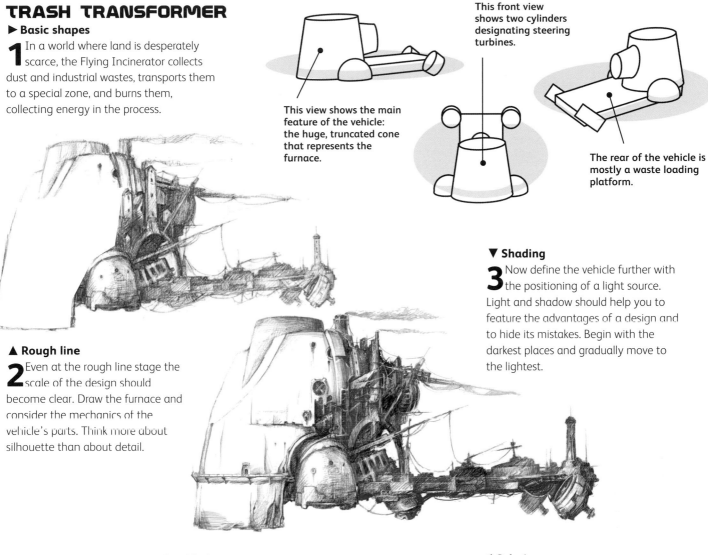

This view shows the main feature of the vehicle: the huge, truncated cone that represents the furnace.

This front view shows two cylinders designating steering turbines.

The rear of the vehicle is mostly a waste loading platform.

▲ Rough line

2 Even at the rough line stage the scale of the design should become clear. Draw the furnace and consider the mechanics of the vehicle's parts. Think more about silhouette than about detail.

▼ Shading

3 Now define the vehicle further with the positioning of a light source. Light and shadow should help you to feature the advantages of a design and to hide its mistakes. Begin with the darkest places and gradually move to the lightest.

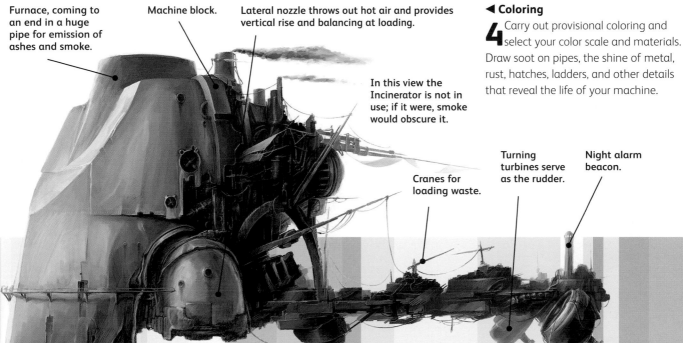

Furnace, coming to an end in a huge pipe for emission of ashes and smoke.

Machine block.

Lateral nozzle throws out hot air and provides vertical rise and balancing at loading.

In this view the Incinerator is not in use; if it were, smoke would obscure it.

◄ Coloring

4 Carry out provisional coloring and select your color scale and materials. Draw soot on pipes, the shine of metal, rust, hatches, ladders, and other details that reveal the life of your machine.

Cranes for loading waste.

Turning turbines serve as the rudder.

Night alarm beacon.

ARTHUR MIRZOYAN

42 LUXURY HOVER CAR

SLEEK STEALTHY AUTO

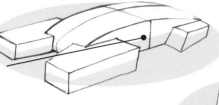

Half of a sphere represents the main aerodynamic shape of the vehicle.

Cubes cut right into the main shape to indicate attachment.

▶ Basic shapes

1 The major shapes and contours of the vehicle body are clearly encapsulated in these basic forms. In the final art, these same major shapes will merge into each other smoothly, forming a more cohesive and aerodynamic profile.

CONCEPT SKETCH

● *Luxury two-seater* ● *Sporty*

Back cubes show consistency throughout the vehicle.

◀ Rough line

2 Many air intakes show how this vehicle hovers. Such details give consistency to a design, and they're fun to add.

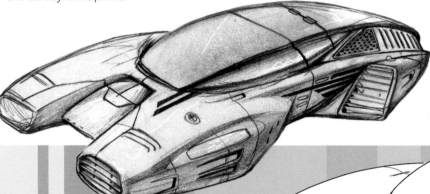

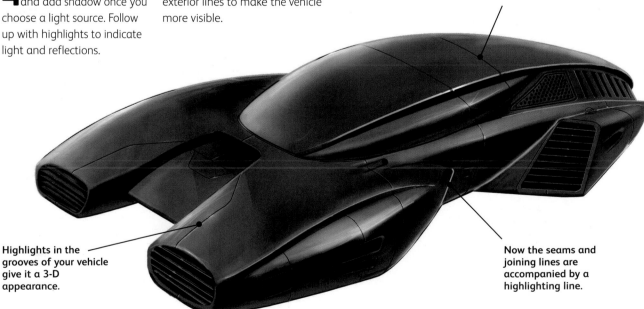

▶ Outlining

3 When you finish drawing, scan your work and trace the main outlines in Illustrator to give them a flawless shape. Thicken exterior lines to make the vehicle more visible.

The seams and joining lines in the car frame are drawn only as thin shadows at this point.

▼ Rendering

4 Lay down a flat color first and add shadow once you choose a light source. Follow up with highlights to indicate light and reflections.

Highlights in the grooves of your vehicle give it a 3-D appearance.

Now the seams and joining lines are accompanied by a highlighting line.

ANTHONY CAMILO

AERO ZOOMER

▶ Basic shapes

1 Curvy shapes arranged in a streamlined way form the Future Bike.

▼ Rough line

2 Choose an angle from which to draw the bike. Plot in the basic shapes to get the overall look and feel, starting with the larger ones. Then add smaller shapes, like the areas around the wheels and exhaust pipes. Next, concentrate on detail work, creating for example interlocking panels with countersunk rivets. Mechanical details add interest to the vehicle's surface.

The basic shapes used here are more plastic and less angular.

The linework on these views is clean and has minimal variation.

CONCEPT SKETCH

- *Rugged* - *Highly engineered*

These basic constructs are already well on their way to fully describing the final art.

▶ Outlining

3 Emphasize the contours of Future Bike with fine line pencil shading.

▼ Rendering

4 This bike requires the color palette of a super-fast road machine. Grays and blues evoke a cold, hard, hi-tech feel. Consider warm grays as highlights and cool grays for shading.

The pencil line shading adds an excellent noise factor to the vehicle's surface, giving it a more tactile appearance.

Even in a series of grays, slight variation in hue and temperature can imply widely varying materials.

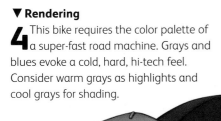

If you add decals to your bike it can be a street racer.

CORLEN KRUGER

44 RS 71 AERO FIGHTER

SPACE FIGHTER

▶ Basic shapes

1 This is a combat space vehicle used for short range dog fighting or for attacking larger ships. Very flat and long shapes give it a quick and slick look, like a vehicle that is impossible to catch and kill.

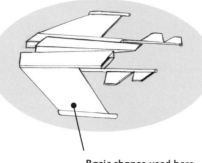

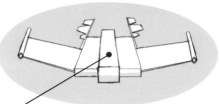

A pyramid gives the feeling of a sharp, space-piercing cockpit.

Two long, rectangular cubes represent the two engines here.

Basic shapes used here are cylinders, cubes, and pyramids.

▼ Rough line

2 Once you are happy with the main shape and have a good silhouette going, you can proceed to add more detail and to design all the intricate parts that give your vehicle more life. When you are done, trace your design onto tracing paper. Make sure it's clean and ready for scanning.

▶ Outlining

3 When you've reached this stage, decide where your light is coming from. Begin shading and blocking out the major shapes.

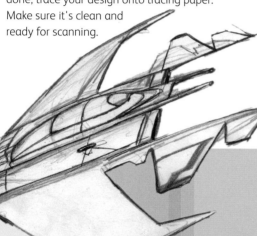

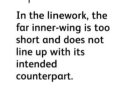

In the linework, the far inner-wing is too short and does not line up with its intended counterpart.

The far inner-wing has been extended in this second pass, so the structure is more balanced.

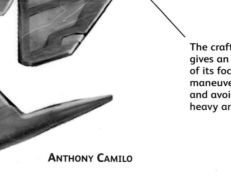

◀ Rendering

4 Add color to the design. Remember to include scratch marks and dirt marks to give it a worn-down feeling.

The craft's thickness gives an indication of its focus on maneuverablility and avoidance over heavy armor.

ANTHONY CAMILO

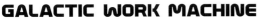

A.C.E. M7

GALACTIC WORK MACHINE

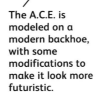

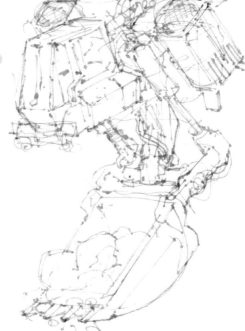

▲ Basic shapes

1 The Agile Construction Equipment Model 7, or A.C.E., is a compact and durable vehicle used to remove obstructions, arrange soil, and transport supplies. Even the basic shapes convey these characteristics and functions.

The A.C.E. is modeled on a modern backhoe, with some modifications to make it look more futuristic.

► Rough line

2 The initial rough sketch is done with a light gray art marker. The marker lines are traced over with a fine-point art pen.

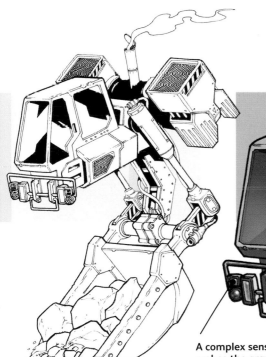

A complex sensor array probes the ground to stop the A.C.E. from digging through underground power cables and data lines.

All intake vents are covered with a tight mesh grate to prevent dig-site debris from being sucked into the engines.

▲ Outlining

3 Use varied line weight to help separate the different parts of your drawing. The different weights help keep a drawing with lots of lines from becoming too jumbled.

◄ Finishing

4 If you have been working in a sketchbook, you may want to trace the design onto nicer paper for the final version. A light box makes this an easy, accurate task.

DAVID WHITE

46 FLUXIA SKATE DX24-7

RUNNER BLADE

Basic shapes such as cylinders and boxes are used to rough out the features of the Skate.

Some of these boxes are elongated to create the unique slim profile of the vehicle.

CONCEPT SKETCH

- Compact • Personal
- Climate controlled

▲ Basic shapes

1 After the Scourge Wars, the polar regions became much colder as the superheated equatorial Scourge lands caused the global weather patterns to destabilize. However, in order to survive, some people were forced to expand into these ice wastelands, and vehicles such as the 100% self-powering Skate were mass-produced to make such endeavors less traumatic.

▲ Rough line

2 The initial drawing is loose and sketchy and explores various design aspects of a single blade with a cabin and engine perched on it.

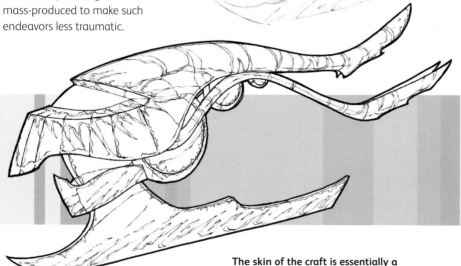

▲ Outlining

3 The sketch is then hand inked with a 0.3 size drawing pen, and finished with a thick marker around the edge. The design is simple at this stage, emphasizing elegance and poise over details.

▶ Rendering

4 Photoshop is used to change the color of the line drawing to a dark greenish blue before textures and colors are added to the craft. As this is a vehicle designed for use in snow and ice, cold blues and greens are an appropriate color scheme.

The skin of the craft is essentially a huge solar panel, absorbing the energy required to power the gyroscopes.

The triple gyroscopes positioned in the center of the vehicle move very slightly around their axis housings to adjust the balance of the craft.

The Skate blade has a "kinetic edge" that creates energy from friction contact with the ice.

KEVIN CROSSLEY

ALIENSBOCO

MEGA MOSQUITO

The basic shapes are ovals, cylinders, and cones.

The craft has three legs, two arms, and a tail to help with balance.

Perhaps this UFO (unlike a normal helicopter) could land on irregular terrain, or even walk.

CONCEPT SKETCH

- Alien
- Hovering
- One-person carrier

▲ Basic shapes

1 NASA found this abandoned UFO in 1974 in Peru. Scientists say this one-seater is a personal research unit. The flight system, featuring insectlike wings, is still incomprehensible to humans.

▶ Rough line

2 In composing your vehicle, include some elements that seem to be from another planet, and others that are like animals or contemporary machines. This leaves room for an intriguing question: Is this an alien vehicle or a human device from the future?

▲ Contrast

3 A balanced contrast is always pleasing to the eye. In the Aliensboco, contrast comes from the dark body paired with lively, alien wings.

◀ Finishing

4 Play with materials. In this vehicle, there are translucent, reflective, and opaque surfaces.

These arms could be weapons, sensors, or even magnetic hands.

JOAO RUAS

48 RAINFOREST OBSERVER

BEETLE PLANET

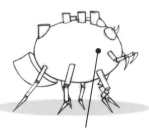

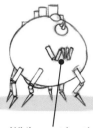

The basic shapes are ovals, cylinders, and cones. The body needs to be massive (it carries a city!).

While most beetles have only three pairs of legs, this one has small praying mantis arms as well. The arms make the vehicle a bit more human and less "weird" to people.

The large chutelike tail allows for efficient waste removal.

CONCEPT SKETCH

- Bulbous organism
- Settlement on surface

▲ Basic shapes

1 The gigantic Observer was conceived by scientists and inspired by their interest in animal life and forests, an interest ever more intense since the rebirth of the world a few decades ago. It is a walking scientific village, and its organic nature (it is a giant beetle) merges with the forest itself. The vehicle is controlled by computers that send electric signals to implants in the animal's brain.

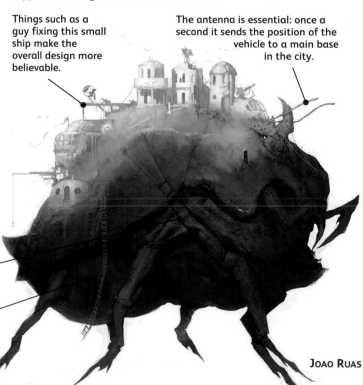

▲ Rough line

2 When sketching, spend time on the focal and more-important points of the picture and do the rest quickly; they are there to support the image, not take the main role.

Things such as a guy fixing this small ship make the overall design more believable.

The antenna is essential: once a second it sends the position of the vehicle to a main base in the city.

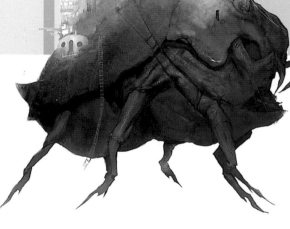

▲ Shading

3 Beetles are almost always dark and shiny creatures, like a polished shoe. At this stage, develop the general light values quickly, without worrying too much about what causes them. It's very important to be happy with the picture here before you start to increase detail, because changes become harder and harder to make.

▶ Rendering

4 The dark, dirty beetle and the bright, clean village create a natural contrast, but at the same time they seem to work together. To give a sunny feel to your paintings, combine a warm light with cold shadows; it always works.

The ropes pressing against the body of the beetle show its contrasting materials: the top is hard, the bottom is fleshy.

This storage area holds supplies that don't fit in the buildings.

JOAO RUAS

NORG GUMBLER

SPIDER RACER

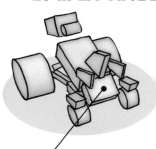

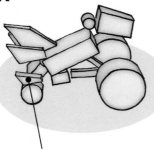

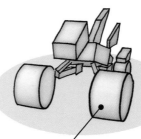

Although quite complex, the vehicle is constructed using simple boxes and cylinders.

Boxes can be distorted to suggest wheel arches, wings, and the tapered pilot cabin area.

Large front wheels can batter attacking arachnid Virithids out of the way.

CONCEPT SKETCH

- *Sporting equipment*
- *Flashy*
- *Single-seater*

▲ Basic shapes

1 "Gumbling" is an extreme racing sport popular on the Betelguesian system planet Vhenk Norg. Competitors must drive their specialized vehicles, or Gumblers, through the nesting environments of extremely vicious arachnid-type creatures.

▶ Pencil linework

2 Render the initial drawing in blue pencil, which can be easily isolated and removed from the finished line art using a digital art program.

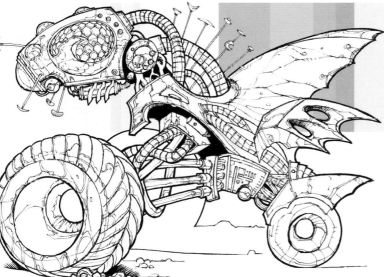

◀ Ink linework

3 Apply black ink freehand using 0.05 and 0.2 drawing pens. Finish with a thick marker outline. The freehand inking enhances the unconventional design. To create surface texture and visual interest, allow the pen line to move very loosely around the paper, adding splotches and spots here and there before finishing with a thick outline.

The body shell is protected by self-repairing organic armor.

The pilot cabin resembles a Virithid head and is mounted on a retractable neck.

▶ Color

4 Apply muted colors using digital tools such as paintbrush and airbrush, with tonal/saturation adjustment altered using the dodge, burn, and sponge tools. Use loose strokes in Photoshop to complement the looseness of the ink line.

Tubes, fuel pipes, and lubricant "veins" reinforce the organic design.

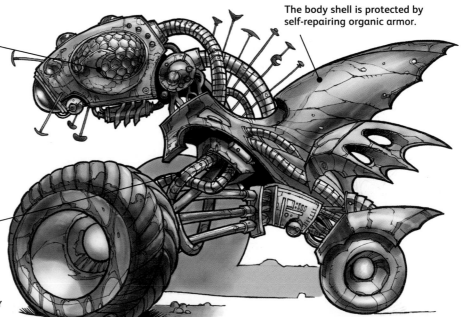

KEVIN CROSSLEY

50 LIGHTWEIGHT FLYER

SWOOP JET

▶ **Basic shapes**

1 The Lightweight Flyer employs a revolutionary front-mounted aileron design to dramatically boost performance. Ancillary flaps added to the latest model aid stability, making it one of least fatal models to be released in years.

CONCEPT SKETCH

- *Birdlike*
- *Super fast*
- *Wide wingspan*

This airplane is intended to look feasible, but not contemporary.

The inspiration comes from a modern airplane's wings, which can expand flaps for increased surface area.

The vehicle was also given a layered look.

▲ **Rough line**

2 Specific details are left out at this point. Major shapes, the curving relation of lines, and patches of light and dark are the main concern.

◀ **Outlining**

3 The outline drawing is fairly static, so add speed lines to suggest motion. By arranging the seating area, you can reveal the pilot, a key to the vehicle's scale.

White streaks from wingtips indicate contrails—trails of vapor seen at altitude.

Blocks of modulated color suggest small panels riveted together to form the surface.

◀ **Rendering**

4 Colors provide a great way to imply weight. Use bright, desaturated colors to make this vehicle seem light and airy. Use dark and richly saturated colors to make other elements of the drawing look dense and heavy by comparison.

DAVID WHITE

SPEED BOAT

ZIPPY SKI CRAFT

▼ Basic shapes

1 Inspired by items as diverse as a tiger shark, a sea scooter, and a multipurpose screwdriver, the Speed Boat's basic shapes are mostly very angular.

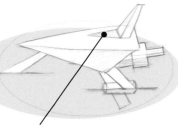

The pointed nose and single seat hint that the vehicle is made for speed.

The ringlike engine shapes are the craft's only curved forms.

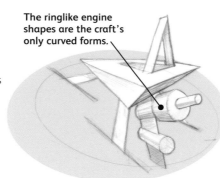

The upright spoiler is reminiscent of a shark fin.

CONCEPT SKETCH

- *One-person carrier* • *Sharklike*
- *Very fast*

▼ Rough line

2 Do a line drawing with a blue animator's pencil. Consider which angle will best show the vehicle's character.

► Tone

3 Scan the line drawing into the computer and work on color and tone using tools including chalk, pen, pencil, glow brush, watercolor brush, and digital airbrush.

One of the two large engines is solar powered, and one runs on air and water.

► Rendering

4 Consider using a different layer for each stage of illustration. The Speed Boat has the following: linework layer; tone layer; color layer; highlight, shadow, and detail refinements layer.

Ski appendages stabilize the boat at high speeds.

DAMIEN ROCHFORD

FLYING CARPET

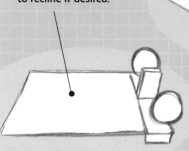

The carpet itself lends plenty of room for the rider to sit or to recline if desired.

This craft is completely symmetrical, and the two fairies are balanced on either side.

A metallic section actually fixes to the rear, and is thicker than the carpet.

From all angles
This craft is structurally very simple; the texture and patterns later add to its complexity. The carpet itself is so thin at this scale that it is presented as a plane with no volume, as opposed to a thin box.

The patterning of the carpet often indicates the family name and house of the privileged rider.

The balls of the front tassels are actually hollowed out and contain polarized energy to act as ballast and prevent the front lip from curling up.

Powered by magic, alchemy, or the forces of nature, these vehicles wend their mysterious way across ancient landscapes. These vehicles are constructed with materials clearly fashioned from natural resources, or harness native beasts as mounts and pack animals.

A MAGICAL AGE

Developing ideas
A well-known "magic carpet" design offered the basis for this craft, and it was decided that elaboration would detail the flying mechanism of the carpet. Whereas captured fairies offer the power source and retain the magical nature of the original idea, mechanical elements are introduced that harness and direct the sorcery.

▲ Flat and sleek, this design works well, but the extra embellishments needed more of a presence.

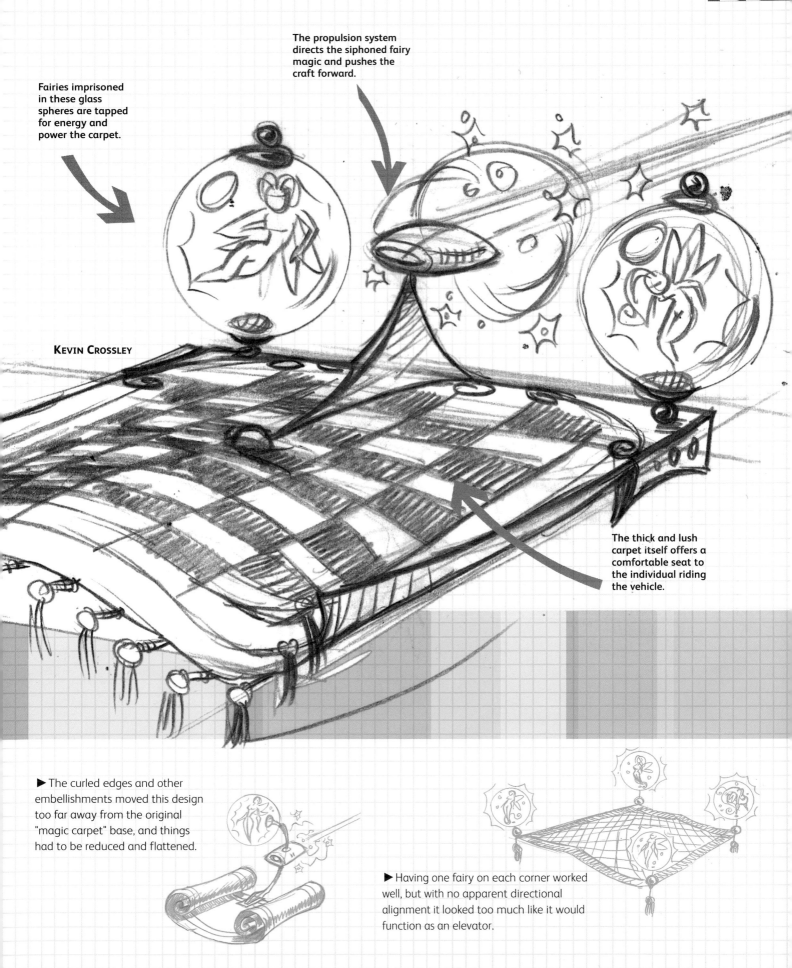

The propulsion system directs the siphoned fairy magic and pushes the craft forward.

Fairies imprisoned in these glass spheres are tapped for energy and power the carpet.

KEVIN CROSSLEY

The thick and lush carpet itself offers a comfortable seat to the individual riding the vehicle.

▶ The curled edges and other embellishments moved this design too far away from the original "magic carpet" base, and things had to be reduced and flattened.

▶ Having one fairy on each corner worked well, but with no apparent directional alignment it looked too much like it would function as an elevator.

The crowning achievement of the burgeoning **Beast Appeaser** caste, Jonah's Fortress has grown to be so **feared** across the known world that its only military use so far has been in coastal bombardment. The monstrous **Fullsman whale** is kept in an almost catatonic state, and extreme body movements are suppressed with a perpetually injected epidural. The whale's prime function is buoyancy, but its pectoral fin movement gives Jonah's Fortress a top speed that far outclasses all known seafaring vessels.

CONCEPT SKETCH

- *Massive* • *Buoyant*
- *Deceptively speedy*

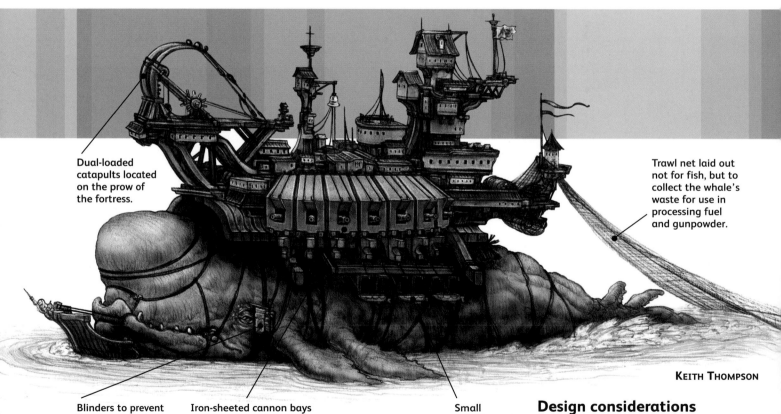

Dual-loaded catapults located on the prow of the fortress.

Trawl net laid out not for fish, but to collect the whale's waste for use in processing fuel and gunpowder.

KEITH THOMPSON

Blinders to prevent the drugged whale from becoming spooked by anything located to starboard or port.

Iron-sheeted cannon bays arranged in an outward curve.

Small complement of lifeboats suspended low, behind the whale's fins.

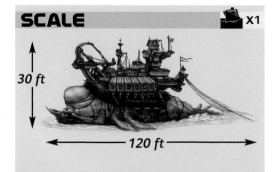

SCALE · X1

30 ft

← 120 ft →

Design considerations

In the case of Jonah's Fortress, scale is of prime importance. Immediately recognizable features, such as the windows in the fortifications, offer an excellent visual key for the viewer to use as a size reference. Focus on the actual details, as well as on producing implied detail with simple line and form variance.

Developing the design

The fortress cannot deform during movement, so ensure that it does not conform too closely to the body of the whale and, instead, sits atop it.

The fortress must appear balanced over the whale's back when viewed from this angle.

The fortress hangs out quite far over the rear of the whale.

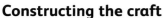

The plane of equilibrium is where the whale emerges from the water.

Constructing the craft

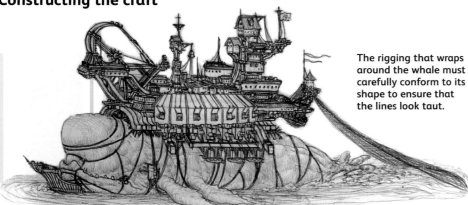

The rigging that wraps around the whale must carefully conform to its shape to ensure that the lines look taut.

▲ Linework

1 Once the linework is completed, little in terms of subject matter will be added. Use ambient pencilwork to fill in the large surfaces of the whale's body.

▼ Shading

2 If you squint while viewing the shaded work as almost a silhouette, a good idea of image readability emerges—the entire piece of art should still be recognizable, even when heavily obscured. The areas that should not be shaded—between the rigging, for example—can be manually cleaned up with the eraser tool.

Now is a good time to tie up any newly discovered loose ends in the linework, but you shouldn't have to fix much.

▼ Coloring

3 Rich, earthen tones can be used universally in this piece. Remember that the water will reflect local colors—often the sky—and in this case much of the fortress, due to its proximity.

Remember that this craft has been at sea for a long time and should not appear too pristine.

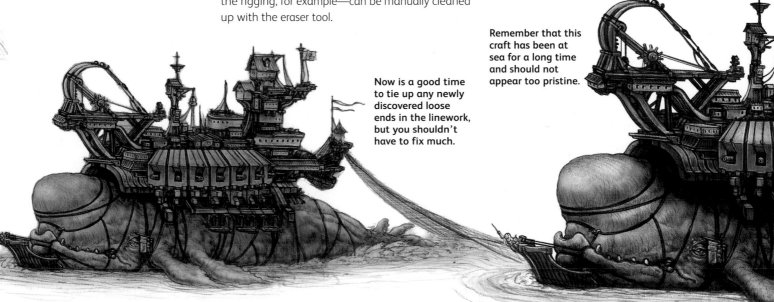

During the great celebrations of Beltane, the **pagan** masses form huge parade lines as they cavort naked and in step with the Wicker Man, whose rider leads them across the landscape. Inside the Wicker Man's structure, the **sacrifices burn** in offering, and a huge intoxicating cloud billows back into the madly **frothing** parade.

Druidic ceremony master blindly steers the Wicker Man toward the faint image of the gibbous moon, which he can just make out through his veil.

The oily, pungent smoke trailing behind the Wicker Man acts as a trance-inducing incense for the following parade.

The reins are merely ceremonial, and the Wicker Man strides forth in a straight line until completely burned down; the location of its halting designates the site for further rites.

The sacrifices that fill the Wicker Man are volunteers but rarely maintain this commitment when the fire is set.

Design considerations
Based upon an historical pagan or Gaelic ritualistic construction, the Wicker Man takes the idea further, animating it and topping it off with a rider. Although it has only one rider, the Wicker Man, as a vehicle, seats something in the range of forty-five sacrificial occupants.

Although mystically powered and animated, the structure of the Wicker Man still needs wooden joints in order to move in its characteristically loping gait.

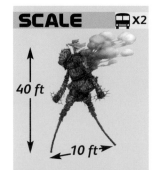

SCALE 🚌x2

40 ft

10 ft

KEITH THOMPSON

Developing the design

The hunched posture is important, but don't worry about craning the head back because the Wicker Man cannot see anything.

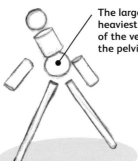

The largest and heaviest section of the vehicle is the pelvic sphere.

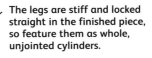

The legs are stiff and locked straight in the finished piece, so feature them as whole, unjointed cylinders.

Walking like a person, the Wicker Man's arms, for balance, swing inversely to the legs.

Constructing the craft

▶ Linework

1 Keep the lines rough and organic, and ensure that the curved bars of the cages of wood are not too precisely aligned.

▼ Coloring

3 The earthy nature of this design cannot be stressed enough, so the colors and textures should be dirty and stained. However, the dirt should look like soil from a forest floor rather than implying that the craft has waded through an industrial oil slick.

The smoke and fire are somewhat loose at this stage, but it's necessary to be conscious of how dominant they will be in the final design.

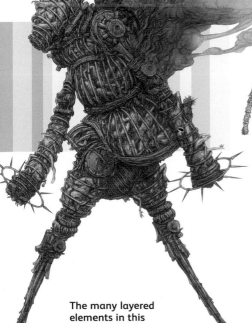

The many layered elements in this design make the shading time-consuming and fussy.

◀ Shading

2 Remember to consider that the contents of the craft are actually of a lighter value than the outer structure: skin inside and wood outside.

The earthy color scheme incorporates wood, bare flesh, and soot.

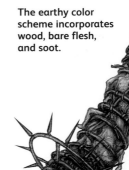

The **pinnacle** of flying-broomstick technology, the Airstreak Sleek 2000 has added luminal engines and **geotropic** phase adjusters so anyone can ride it! Debuting at the 2067 **Modern** Witch and Magician Exhibition, the 2000 has now outsold every other model on the market.

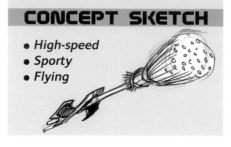

CONCEPT SKETCH

- *High-speed*
- *Sporty*
- *Flying*

Design considerations

The extremely high speeds achieved on this vehicle are implied with a dragsterlike profile. A huge, imbalanced rear, with tangled exhausts and obvious weight, propels a tapered and structurally simpler vehicle frame. A purposely old-fashioned broom head contrasts with the rest of the metallic vehicle.

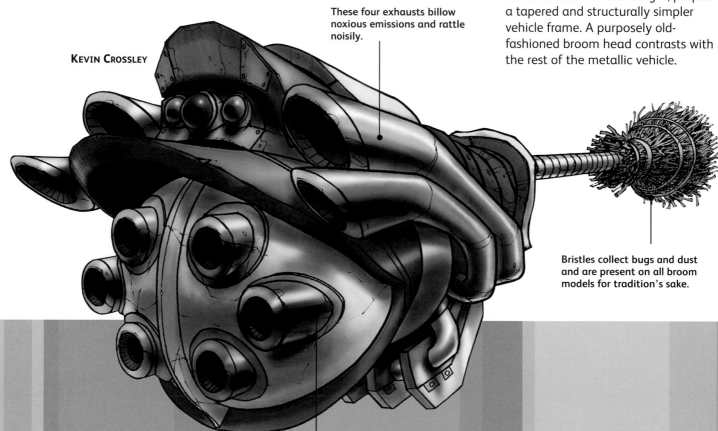

KEVIN CROSSLEY

These four exhausts billow noxious emissions and rattle noisily.

Bristles collect bugs and dust and are present on all broom models for tradition's sake.

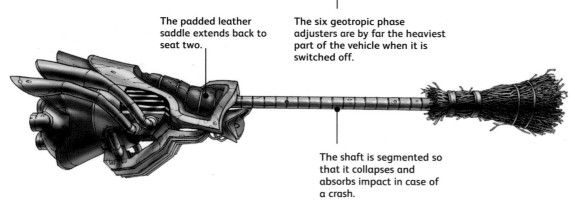

The padded leather saddle extends back to seat two.

The six geotropic phase adjusters are by far the heaviest part of the vehicle when it is switched off.

The shaft is segmented so that it collapses and absorbs impact in case of a crash.

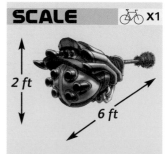

SCALE
X1

2 ft

6 ft

Developing the design

Simply put, this vehicle is a broom with an engine on the handle end. It is presented horizontally and in the position that would be used during normal operation.

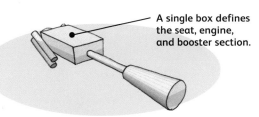

A single box defines the seat, engine, and booster section.

Basic shapes are cylinders, boxes, and cones, adjusted to the vehicle's dimensions.

The angle of this image gives dynamic perspective.

Simple angled cylinders indicate exhaust pipes and add dynamic visual balance.

Random lines and spots add interest and give further texture and detail to the finished art.

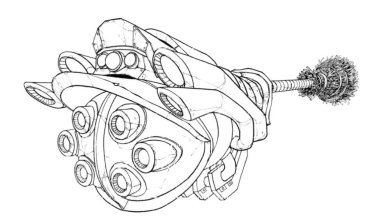

Constructing the craft

◄ **Sketching**

1 Develop the initial sketch on paper and turn it into a three-dimensional reference model on the computer. First, block out the model using basic shapes; then, define and refine the individual design elements. Use this detailed model as reference for the finished two-dimensional artwork.

► **3-D mock-up**

2 Render the thumbnail sketch as a snapshot image. Then, make a refined line drawing using the three-dimensional model as reference. Do this using a computer art package or ink or pencils.

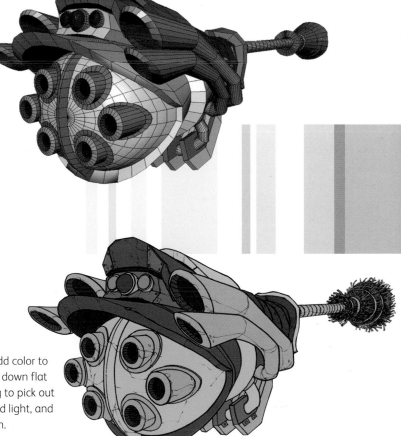

▼ **Shading**

3 Lay in defined areas of light and dark. Set the darkest points of shadow in the hollows of the exhaust pipes and open ports of the phase adjusters.

► **Color**

4 Use Photoshop to add color to the line art. First, lay down flat color. Then, add shading to pick out highlights, show reflected light, and add weight to the design.

Polished to a glittering shine, Sir Maximillian's new **siege engines** scuttle along battlefields, lobbing mortar rounds into the citadel walls of the neighboring fiefs. It is whispered that the lord has fashioned a pact with **Beelzebub** in exchange for the arcane knowledge required to manufacture such **unnatural** weapons of war.

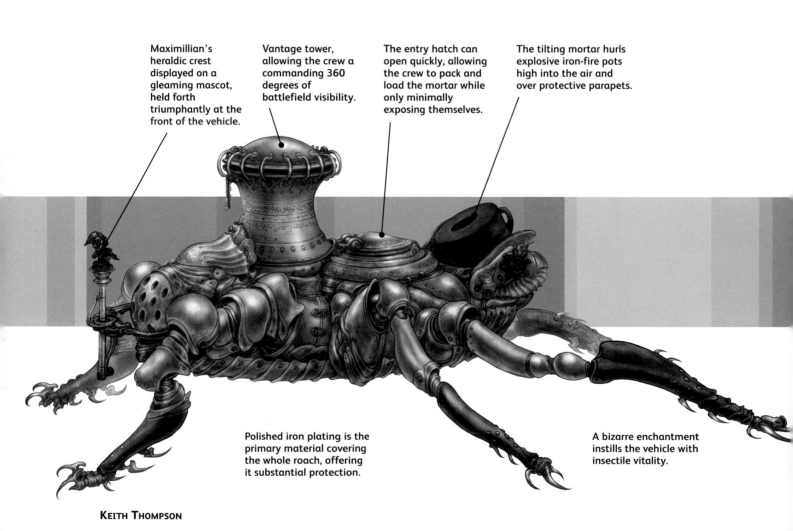

Maximillian's heraldic crest displayed on a gleaming mascot, held forth triumphantly at the front of the vehicle.

Vantage tower, allowing the crew a commanding 360 degrees of battlefield visibility.

The entry hatch can open quickly, allowing the crew to pack and load the mortar while only minimally exposing themselves.

The tilting mortar hurls explosive iron-fire pots high into the air and over protective parapets.

Polished iron plating is the primary material covering the whole roach, offering it substantial protection.

A bizarre enchantment instills the vehicle with insectile vitality.

KEITH THOMPSON

Design considerations
This careful composition replaces an insect's carapace with plates from period suits of armor and, much like the armor that inspires it, manages to mix decorative shapes and aesthetics with carefully planned functionality. Even purely functional parts, such as the mortar, have a degree of decorative embellishment.

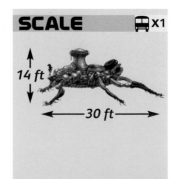

SCALE 🚌X1

14 ft

30 ft

Developing the design

Ensure that the trajectory of the mortar (always a high angle) is not positioned to take off the top of the turret when fired. Because it is based on a complex organism, keep the vehicle bilaterally symmetrical.

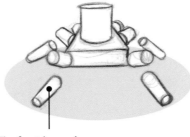

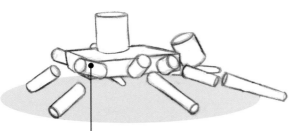

The front legs splay outward in a V-shape.

The legs' first segment angles upward from the body, and the following two segments angle downward.

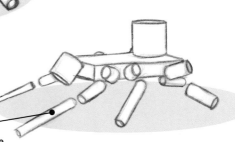

The two rear legs are the most muscular, and are almost twice the length of the front two sets

Constructing the craft

▼ Linework

1 It would be rare for two plates of armor to meet flush, so ensure that one plate seems to continue underneath a joining.

Rich, showy colors can be used liberally in this design because they ostentatiously display the wealth of the owner.

Even in the linework, make sure it is obvious which armor plates overlap and which underlap.

▼ Shading

2 Although high contrast is necessary here for the materials used, leave the bright, shining highlights until the color stage.

The mascot helps to contextualize the vehicle.

▲ Coloring

3 Splash around intense spots of reflected color and then obscure most of this color with bright white highlights so that color runs along the edges of the white patches.

The temple and surrounding dwellings on this island were built by a religious **cult**; it now floats across the continent indoctrinating new followers. Of course, the more established religions on land encourage all to resist the new cult, and attacks on the island are common. It floats and very slowly steers through the use of **huge lodestones**, and peasants on the ground are taught to set **fires** in its path.

KEITH THOMPSON

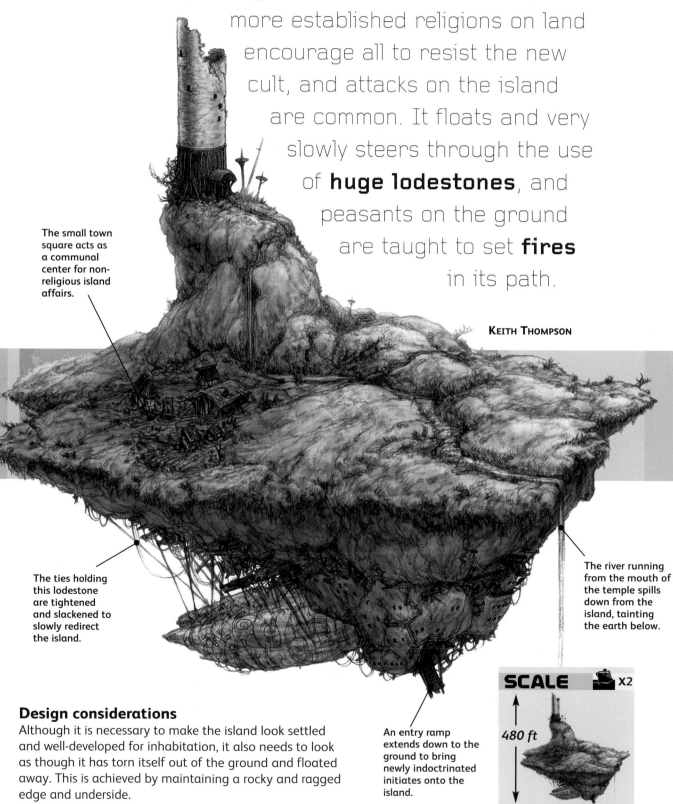

The small town square acts as a communal center for non-religious island affairs.

The ties holding this lodestone are tightened and slackened to slowly redirect the island.

The river running from the mouth of the temple spills down from the island, tainting the earth below.

An entry ramp extends down to the ground to bring newly indoctrinated initiates onto the island.

SCALE X2

480 ft

500 ft

Design considerations
Although it is necessary to make the island look settled and well-developed for inhabitation, it also needs to look as though it has torn itself out of the ground and floated away. This is achieved by maintaining a rocky and ragged edge and underside.

Developing the design

The cone is simply a rocky extension on the rough underside of the island. The finished version depicts this outcropping with a network of windows cut into it.

The tower jutting high up from the island's surface is the focus of the design.

The top of the island needs to be kept relatively clear for the agricultural use of the inhabitants.

The lodestone hangs down from the center of the island for balance.

Constructing the craft

▼ Linework

1 When working on so many elements depicted at such a distance, the linework must be strategically used to match the level of detail necessary for the vehicle's scale. Instead of drawing small details like a window frame, draw the cavity shadow of the whole window.

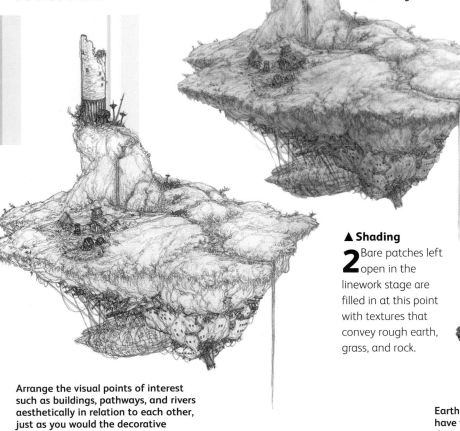

Gradually shifting values are used for shading.

▼ Coloring

3 Although the overall hue of the grass surface of the island should be green, mix in as many warm colors as you are comfortable with. Sections such as the roads and pathways crisscrossing the island should shift hues to a brown or yellow.

▲ Shading

2 Bare patches left open in the linework stage are filled in at this point with textures that convey rough earth, grass, and rock.

Arrange the visual points of interest such as buildings, pathways, and rivers aesthetically in relation to each other, just as you would the decorative engravings on a plate of armor.

Earth tones obviously have their place in this design, but play around with hues in the lighting and overall color scheme.

- *Fierce*
- *Powerful*
- *Warrior*

Long ago, the god Loki, in the form of a **white mare** and impregnated by the horse Svadilfari, gave birth to Sleipnir, the **eight-legged**. When Loki reverted to his natural form, he gave Sleipnir to the god Odin, announcing that the steed could carry his rider more swiftly than any horse by land, sea, or air, and had the power to enter the land of the **dead** and return.

The tail is not bobbed, but tied up on itself to prevent it being used as a handhold in battle.

KEITH THOMPSON

Runes instill the steed with protection from ice giants and the grasping hands of the dead.

The six legs at Sleipnir's front can lay down a vicious barrage of levades during an airs-above-the-ground mezair dressage maneuver.

Heavy iron-shod shoes can dash the heads of ice giants.

Design considerations
Careful reference needs to be used when depicting even modified real-world animals to ensure that the accurate musculature of the horse supports the fantastical additions.

SCALE X1

24 hh

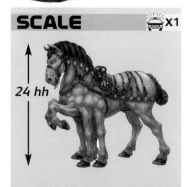

Developing the design

Keep all the legs a consistent length, especially the pair held up at the front. The two forelegs point inward toward each other as they are raised.

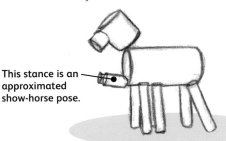

The legs are all anteriorly aligned along the body.

This stance is an approximated show-horse pose.

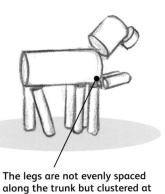

The legs are not evenly spaced along the trunk but clustered at muscular anchor points.

Constructing the craft

▶ Linework

1 As in drawing a person, the initial gestural life drawing of the horse is one of the most important steps in the art, so be sure you are fully satisfied before moving on.

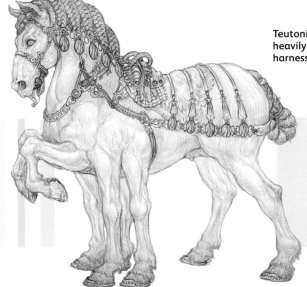

Teutonic styles have been heavily worked into the harnessing and designs.

▼ Shading

2 An understanding of the anatomy of the horse needs to be maintained in the shading step in order to keep the volume of the muscles and tendons accurately proportioned.

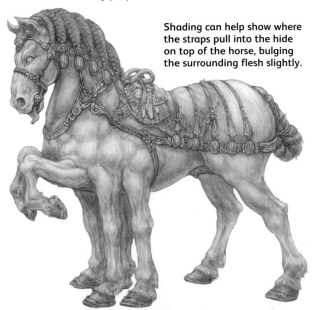

Shading can help show where the straps pull into the hide on top of the horse, bulging the surrounding flesh slightly.

▶ Coloring

3 In terms of color, you have a huge amount of freedom, conceptually speaking, because you are dealing with a divine horse ridden by a god.

Use complementary hues to contrast and separate the harnessing from the hair of the horse.

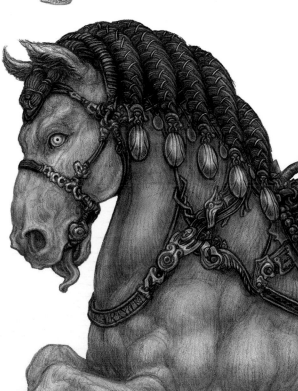

Hunters use the Aranir (sky dragon) ship to hunt the Kranirii **dragons** in the northern Ur-Frai cliffs. The dragons **terrorized** the clan's folk for decades, until the clans started fighting in the air. The zeppelin is made from dragon hide, and the hull made from the strongest oak, soaked with dragon **blood** for extra protection.

The hide forming the balloon is cured, stiffened, and stretched over a dragon rib bone skeleton.

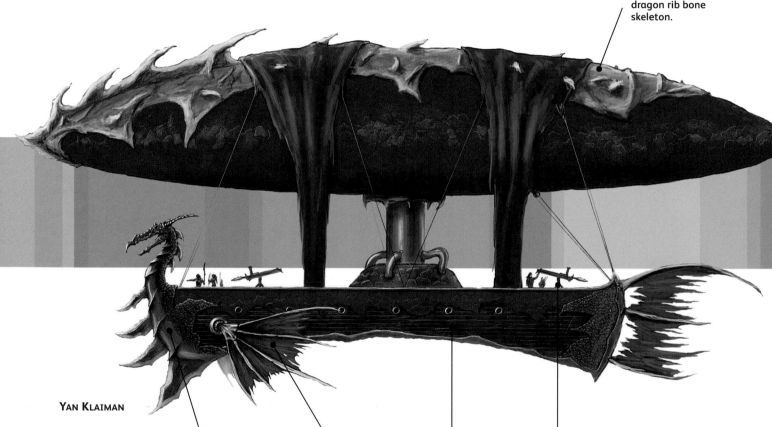

YAN KLAIMAN

The carved dragon intimidates enemies and carries a magical charm.

Fins allow the craft to bank faster than normal.

The hull is made of oak.

Harpoon ballistas pivot on mounts to make them effective on fast-moving targets.

Design considerations

This aircraft is from a fantasy era. It uses a balloon to stay in the air. Made and used by Viking-like warriors, it is hardened with strong but light materials, such as dragon hide and wing skin.

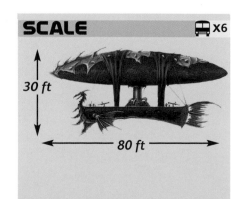

SCALE 🚌 x6

30 ft

80 ft

Developing the design

The proportions of the zeppelin can be different to those of the ship's hull, but in this craft they are equal.

The balloon has more volume than the hull.

The balloon is aligned slightly farther forward than the underhanging hull.

The hull hangs straight down and should line up vertically with the balloon.

Constructing the craft

▶ Loose linework

1 First lay down the base for the final artwork. Focus on getting the right proportions, but don't get into details in this step.

▼ Linework

2 After you have set the proportions you can enter more detail.

▶ Shading

3 When shading, don't forget to add war scars on the body of the ship.

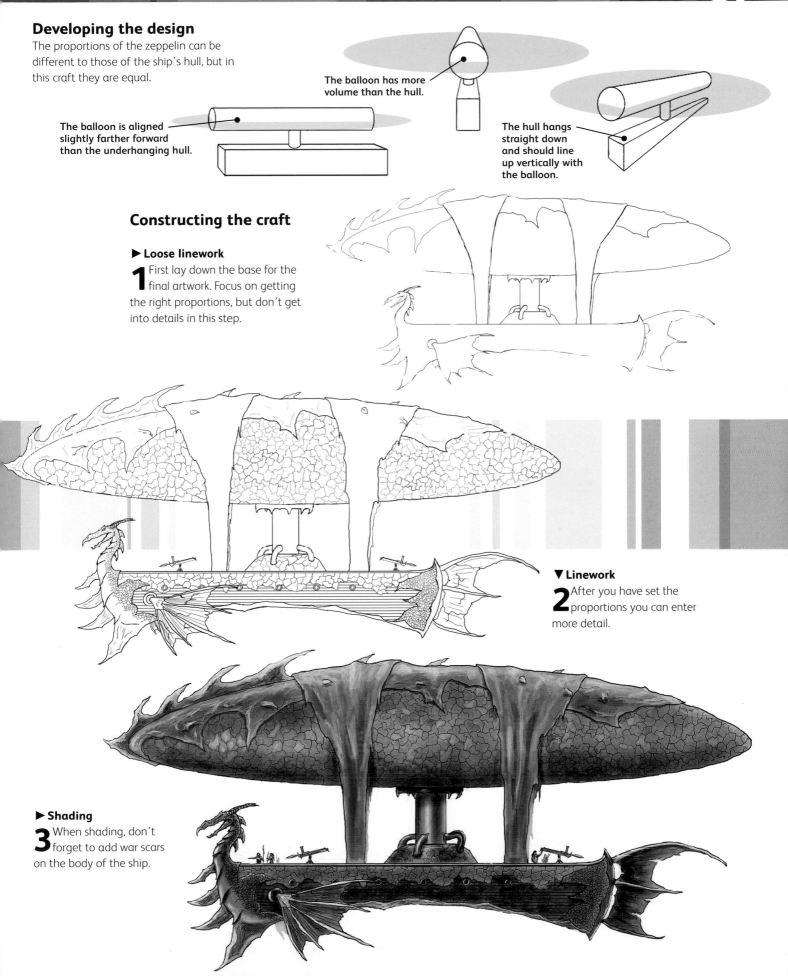

The streets hush and a **deathly pall** descends over the populace when the Strangled Thane's procession shuffles by, surveying the provinces. Carried on the **twisted** shoulders of ascetics, the palanquin stiffly bobs back and forth, its rider sitting on his throne above a seething sea of silently **devout** followers.

KEITH THOMPSON

The thane is kept partially hanged from this gallows at all times, by which means he maintains a persistent state of enlightenment.

Only the highest-tier ascetics of the Strangling are granted the honor of bearing the palanquin upon their shoulders.

The cowled ascetics bear the sign of the "calming noose" emblazoned upon their veils.

Design considerations
Palanquins have been used by a variety of cultures and come in many forms, carried by differing numbers of servants. This palanquin is quite large and has room for more than just the rider, allowing it to function as a mobile altar as well as a mode of transportation.

Peasants may approach and place small offerings to the thane in this vessel.

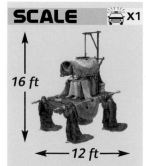

SCALE 🚗X1

16 ft

12 ft

Developing the design

Because the palanquin's load is held on the carriers' shoulders, it is placed almost at the same level as their full height. The canopy and chair sit atop the palanquin base and should align with the same perspective lines.

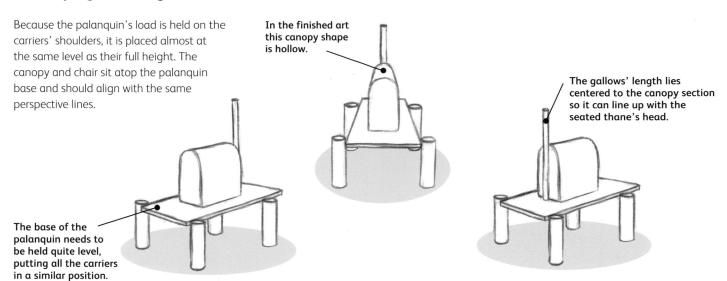

In the finished art this canopy shape is hollow.

The gallows' length lies centered to the canopy section so it can line up with the seated thane's head.

The base of the palanquin needs to be held quite level, putting all the carriers in a similar position.

Constructing the craft

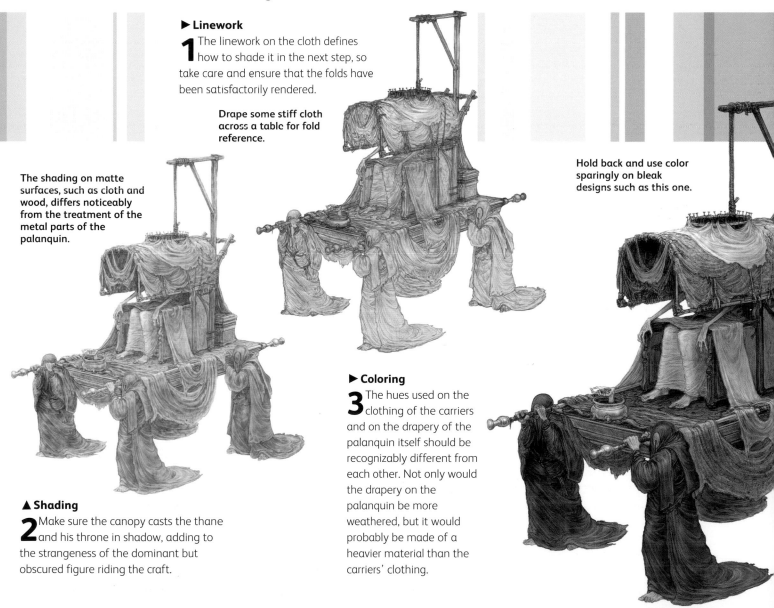

▶ Linework
1 The linework on the cloth defines how to shade it in the next step, so take care and ensure that the folds have been satisfactorily rendered.

Drape some stiff cloth across a table for fold reference.

The shading on matte surfaces, such as cloth and wood, differs noticeably from the treatment of the metal parts of the palanquin.

Hold back and use color sparingly on bleak designs such as this one.

▲ Shading
2 Make sure the canopy casts the thane and his throne in shadow, adding to the strangeness of the dominant but obscured figure riding the craft.

▶ Coloring
3 The hues used on the clothing of the carriers and on the drapery of the palanquin itself should be recognizably different from each other. Not only would the drapery on the palanquin be more weathered, but it would probably be made of a heavier material than the carriers' clothing.

As the **pandemic** sweeps the known world, society's crumbling infrastructures desperately try to form organized methods of disposing of the **insurmountable** numbers of dead. Criminals are co-opted into becoming the drivers of the plague carts in exchange for pardons that they invariably **never survive** to enjoy. These carts trundle through streets ringing their distinctive bells as the driver croaks as loudly as he can, compelling the peasants to emerge from their homes to fill the cart with their mass-burial-destined dead.

CONCEPT SKETCH

- *Grisly* • *Pestilent* • *Slow-moving*

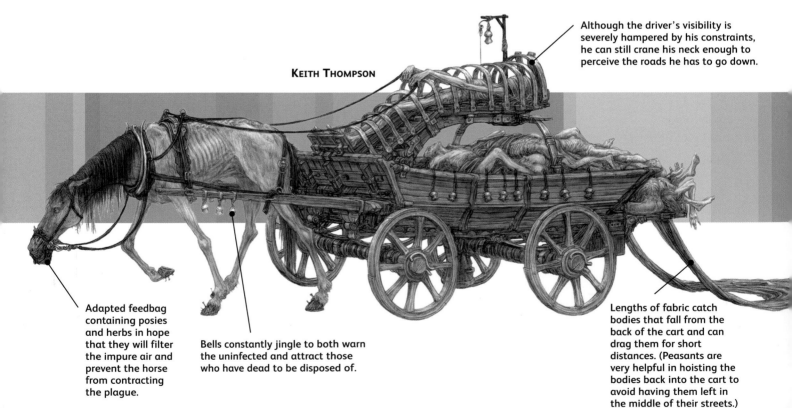

KEITH THOMPSON

Although the driver's visibility is severely hampered by his constraints, he can still crane his neck enough to perceive the roads he has to go down.

Adapted feedbag containing posies and herbs in hope that they will filter the impure air and prevent the horse from contracting the plague.

Bells constantly jingle to both warn the uninfected and attract those who have dead to be disposed of.

Lengths of fabric catch bodies that fall from the back of the cart and can drag them for short distances. (Peasants are very helpful in hoisting the bodies back into the cart to avoid having them left in the middle of their streets.)

Design considerations
This vehicle fills a mundane and bleak role, and everything about its appearance supports this. Worn and shoddy, perhaps ready to fall apart at any given moment, the plague cart reflects a tragically ill world about to cave in on itself.

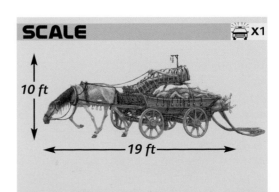

SCALE 🚗 X1

10 ft

19 ft

Developing the design

The wheels are positioned farther to the front of the cart, not evenly spaced. The function of the cart is cargo delivery, so be sure the open bed has plenty of room.

Despite the odd position the driver is forced into, he still has visual clearance over the back of the horse.

The horse needs to be positioned with enough clearance from the front of the cart so that the movement of its hind legs is not impeded.

The legs of the horse should be in the correct position for a walking pace.

Constructing the craft

▶ Linework

1 The horse is so thin and bony that its lines are far more angular and less flowing than if it were healthy.

A lot of the rough texturing is defined even in the pencilwork stage.

The wood and metal of the cart are much darker than the pale horse, driver, and cargo.

◀ Shading

2 Shading without too much contrast implies the mood of a dreary, overcast day, which supports the theme of the design.

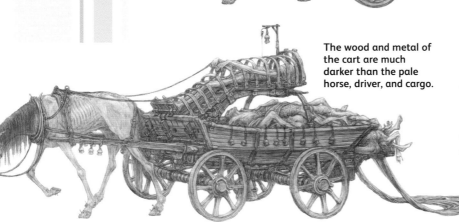

▶ Coloring

3 The amount of filth and putrescence can hardly be overdone in this design. Try to present concentrations of colorful effluence, as opposed to distributing it evenly across the vehicle.

Use overall pale hues intermittently interrupted with vivid sores and buboes.

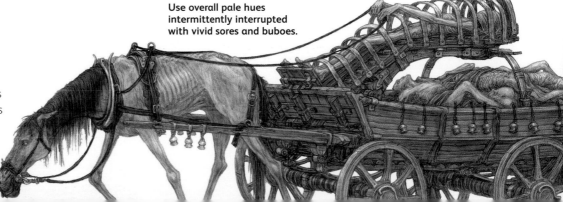

RAIL ROCKET

In this view it is distinctly noticeable how the carriages taper downward.

This angle shows how tall and thin the cars are, almost like buildings on tracks.

Even in perspective, it is apparent that the engine is slightly longer than the adjoining car.

From all angles
Although structurally this vehicle could almost be summed up by two separate boxes, elements such as the lower projections and cylindrical wheel wells are included.

Steel and steam power combine to produce marvels of engineering and workmanship. Personal touches of craftsmanship are clearly visible on vehicles of this age, with gilding, brasswork, and sculptured effects softening the cold, hard, soulless metal.

Though indicated only by wheel well covers, these features show that wheels are used in the vehicle's movement, obscured though they may be.

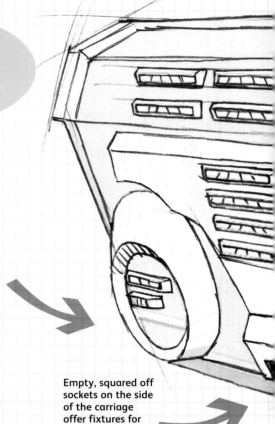

Empty, squared off sockets on the side of the carriage offer fixtures for extra cargo containers.

INDUSTRIAL
REVOLUTION

Developing ideas
Well-engineered but slightly clunky could sum up the impression aimed for in this train design. The engine and one car would have to be designed, and the car could be repeated as necessary down the train's full length.

▶ The car connection has been settled, but the horizontal bands of windows look too regular and contemporary.

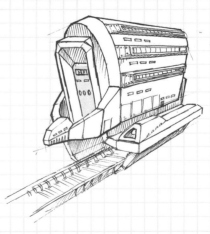

The bays of horizontal windows indicate that this vehicle is for passenger transport (at least these cars are).

The thick plating and solid construction indicate the train is intended for passage through some very harsh environments.

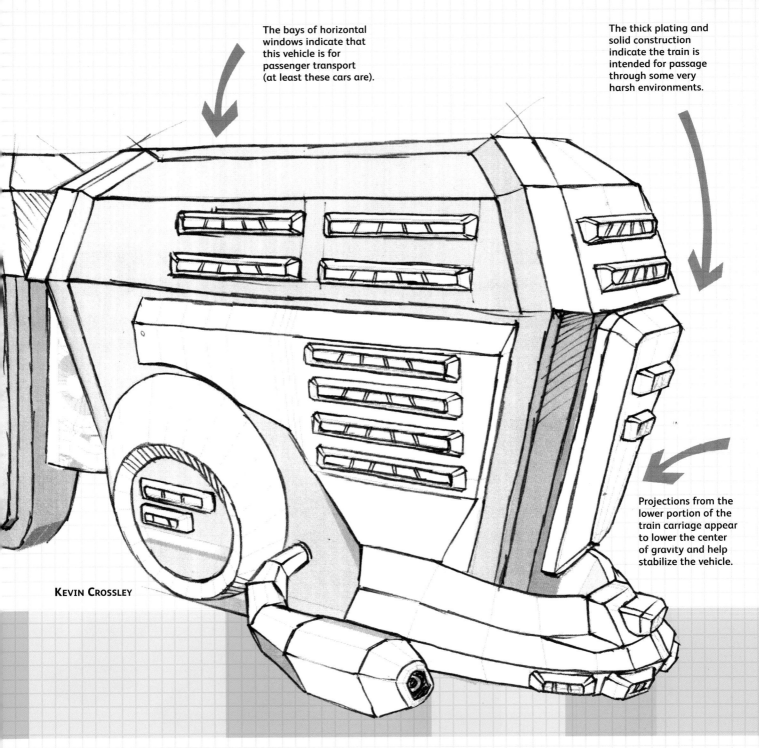

KEVIN CROSSLEY

Projections from the lower portion of the train carriage appear to lower the center of gravity and help stabilize the vehicle.

▶ The same car connection is working well here, but these windows would simply stare into the adjoining car face.

▶ This version ended up appearing too sleek and smooth for the overall intended feel.

74 STEAM SPIDER

Long in development, but first used in the Boer War, the Steam Spider proved tremendously **efficient** in almost single-handedly **demolishing** fortifications and blockades. However, it proved less useful against the common **guerilla** actions it was forced to deal with.

CONCEPT SKETCH

- Destructive
- Powerful
- Lumbering

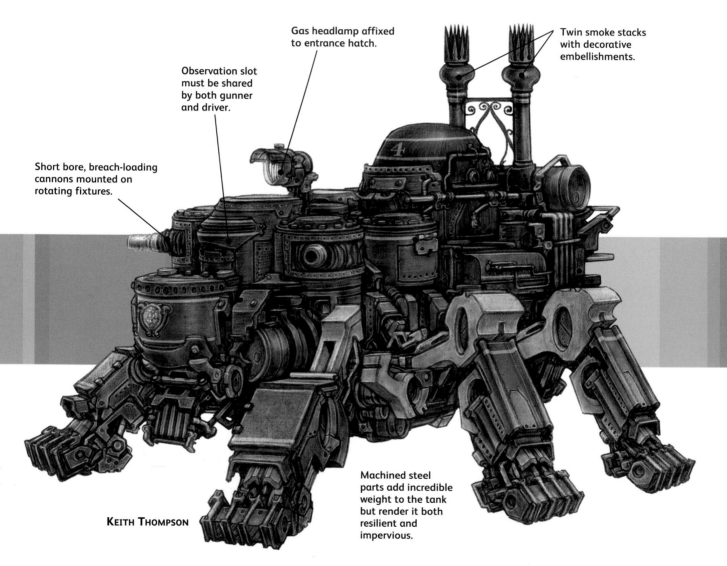

Gas headlamp affixed to entrance hatch.

Twin smoke stacks with decorative embellishments.

Observation slot must be shared by both gunner and driver.

Short bore, breach-loading cannons mounted on rotating fixtures.

Machined steel parts add incredible weight to the tank but render it both resilient and impervious.

KEITH THOMPSON

Design considerations

A good example of the classic line of fantasy vehicles that use limbs for locomotion, the Steam Spider borrows elements of design from the steam engines of its era.

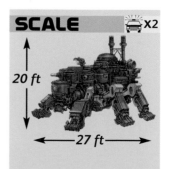

SCALE X2

20 ft

27 ft

Developing the design

The cylinders work well in conveying the fundamental shape, especially since the finished art remains basically cylindrical. Although the legs are angled in differing directions, the slant is the same on each one.

The legs are stiff and static, impressing a sense of stability, but not particularly of agility or speed.

The four back legs are clustered together close to the rear, where the vehicle's mass is greatest.

As with many insects, the rear, where an abdomen would be located, is the bulkiest part of the vehicle.

Constructing the craft

► Linework

1 Although showing a degree of Victorian craftsmanship, the linework should still convey a clunky, smelly, and uncomfortable vehicle.

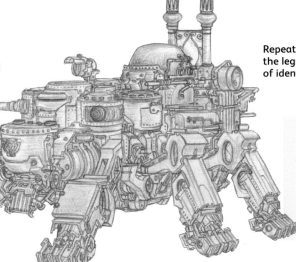

Repeated elements, such as the legs, must appear to be of identical proportion.

▼ Shading

2 In pieces such as this, with an overall heavy value, it can be a good idea to lay in blanketed overall darks when shading, then apply highlights with additive whites.

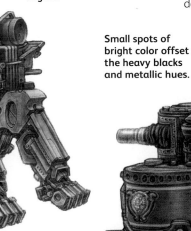

A lot of darks are used so that the finished piece will have the soot black appearance of a period steam engine.

▼ Coloring

3 Subtle splashes of color are still necessary in dark, monochromatic pieces like this one. Apply small flourishes of bright gilding to complement the large, dark patches.

Small spots of bright color offset the heavy blacks and metallic hues.

76 AIRTANKER

A heartwarming sound to many soldiers, the purr of an airtanker's many **ornithopter blades** means supplies are arriving. Since the colonization of Mars began in the late nineteenth century, **territorial** squabbles have continued unabated. The biggest battles are fought around ancient Martian ruins as the opposing factions continue to **plunder** alien technologies for a military advantage.

CONCEPT SKETCH

- *Inflated*
- *Floating*
- *Cargo carrier*

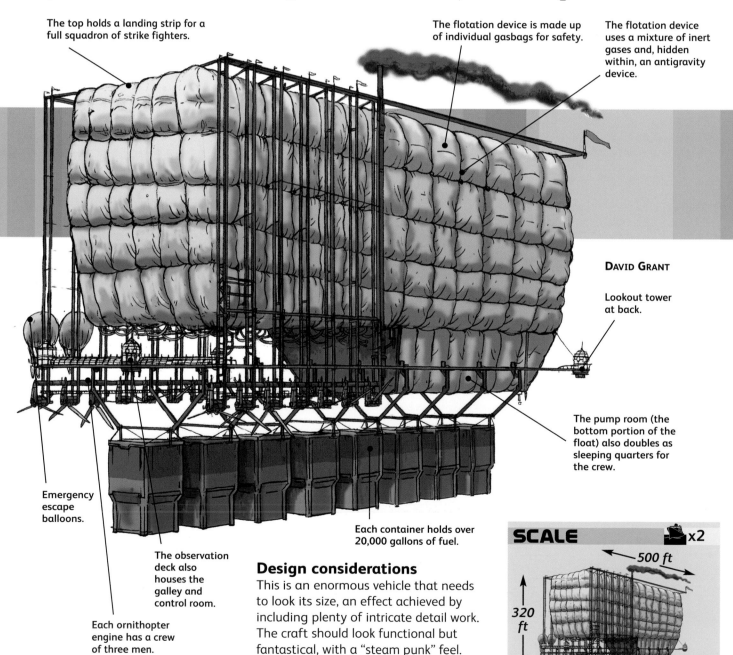

The top holds a landing strip for a full squadron of strike fighters.

The flotation device is made up of individual gasbags for safety.

The flotation device uses a mixture of inert gases and, hidden within, an antigravity device.

DAVID GRANT

Lookout tower at back.

The pump room (the bottom portion of the float) also doubles as sleeping quarters for the crew.

Emergency escape balloons.

The observation deck also houses the galley and control room.

Each container holds over 20,000 gallons of fuel.

Each ornithopter engine has a crew of three men.

Design considerations

This is an enormous vehicle that needs to look its size, an effect achieved by including plenty of intricate detail work. The craft should look functional but fantastical, with a "steam punk" feel.

SCALE

x2

500 ft

320 ft

Developing the design

The major elements of the vehicle's construction are the gasbags, a structural frame, and the row of containers suspended below. The gasbags are basically rectangular, but some slight structural shifts and sloping lines add interest that a more basic shape would not have.

The ornithopter engines are clustered at the front of the craft.

The frame is more developed at the front of the craft, and the pump room makes the gasbags appear to extend down at the rear.

The gasbags comprise the bulk of the craft's size.

Constructing the craft

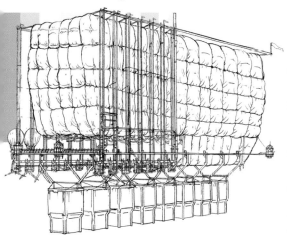

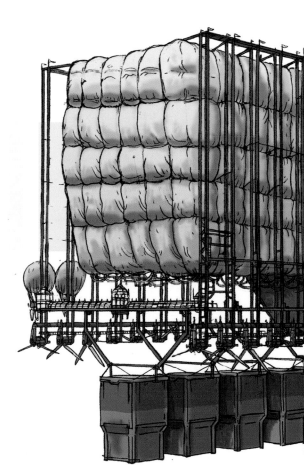

◀ Linework

1 Working from a sketch, build the basic shapes of your vehicle in a three-dimensional computer program. Print out a faint copy of the 3-D model and draw over it with a fine mechanical pencil, using the initial sketch as reference. Develop key design items such as the driver's cabin, wheel positions, and cargo compartments. Add extras: impact bars, lights, and air intakes. This method allows you to mix the naturalness of hand-drawn art with the accuracy of computer rendering.

▶ Shading

2 Scan the finished linework into Photoshop and place a Multiply layer on top. In this layer you can make a complete mask of the vehicle in a 20 percent gray, which can be utilized afterward as a border for shading and for coloring. Select a medium brush to shade, and consider your light source, because accurate rendering of light and shadow will really add to the believability of the vehicle. Use a smaller brush to add scratches and scuffs and emphasize folds in the material.

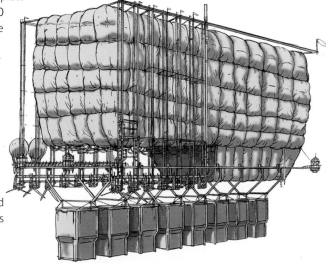

▲ Coloring

3 To color, add another Multiply layer and use the Shading selection to add flat colors that work together. There is a lot of fine detail in this craft, so contrast in colors is important; otherwise, the detail would tend to be lost. At the same time, however, you don't want the artwork to be garish, so keep the emphasis on pale and dark colors of a similar hue. Add an Overlay layer to give more light contrast.

After receiving V-2 rocket plans, **plutonium**, and uranium oxide snuck into Japan by the Global Arms Network, a secret research cell applied the new technology to the preexisting **Cherry Blossom kamikaze** plane. This new jet was to function as a human-piloted atomic bomb, to be deployed mid-flight from bombers.

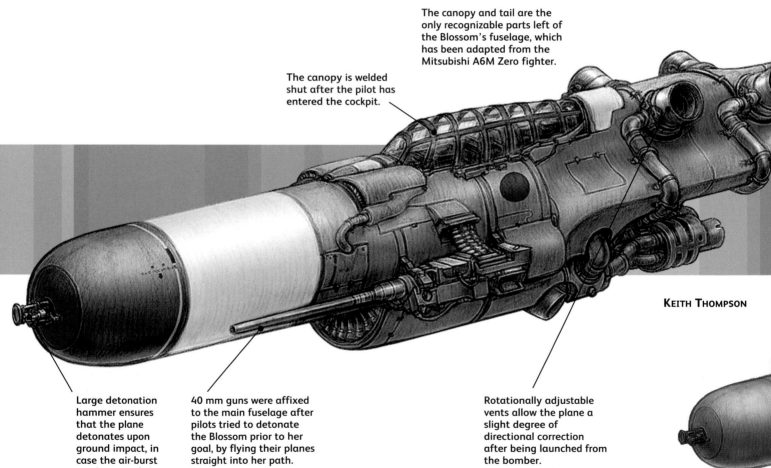

The canopy and tail are the only recognizable parts left of the Blossom's fuselage, which has been adapted from the Mitsubishi A6M Zero fighter.

The canopy is welded shut after the pilot has entered the cockpit.

KEITH THOMPSON

Large detonation hammer ensures that the plane detonates upon ground impact, in case the air-burst mechanisms fail.

40 mm guns were affixed to the main fuselage after pilots tried to detonate the Blossom prior to her goal, by flying their planes straight into her path.

Rotationally adjustable vents allow the plane a slight degree of directional correction after being launched from the bomber.

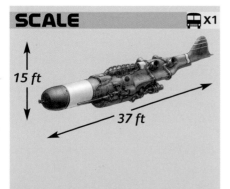

SCALE 🚌 x1

15 ft

37 ft

Design considerations
Based on existing historical technology, this design is a hybrid of a Japanese fighter plane, German jets, and the American atomic bomb. Although the design is purely fantastical, it cannibalizes existing parts from a myriad of real-world vehicles and devices.

Developing the design

The raised portion of the middle cylinder coincides with the fore-facing panel of the canopy windshield.

Sleek and purposeful, from the front it is clear that the plane is not much more than a piloted missile.

The most dominant portion of the vehicle is the huge bomb shape, comprising the entire nose and front of the plane.

The whole structure inclines toward the nose, with the tail the most raised part.

The tail fuselage is raised high to give the main jet engine, on the bottom of the plane, plenty of clearance.

Constructing the craft

▼ Linework

1 When working with a design that so closely mimics real-world counterparts, think carefully before adding flourishes.

The craft borrows elements and details from World War II fighter plane references.

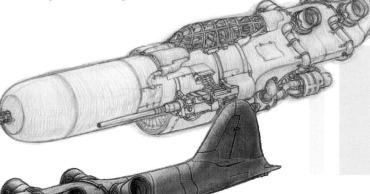

◀ Shading

2 Remember to strategically break up smooth parts of the plane with highlights and shading that depict the joints of plating and panels.

Historical insignia and markings add to the richness of the design.

Shading is quite straightforward on this uniform shape: lighter on top and darker on the bottom.

▶ Coloring

3 It is imagined that the kamikaze pilots had some freedom to decorate their vehicle in a glorious fashion, considering their touted, sacrificial role. However, remember that the hues must retain a drab appearance for the more functional parts of the plane, such as the jets and the gun.

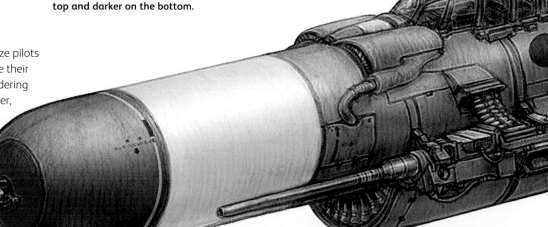

An iconic symbol of **empire**, Seahorse has been **fighting fires** at British docks since entering service in 1860. Despite **temperamental** handling and high maintenance, Seahorse is popular with its pilots. Of twenty-five surviving models, five are still operational and draw enthusiastic crowds when they appear.

CONCEPT SKETCH

- *Paddle wheel*
- *Emergency vehicle*
- *High-quality manufacture*

Design considerations

Seahorse hails from Victorian times, the height of Great Britain's industrial age, so it must reflect the solid workmanship and design ethics of its time. It should appear solid, functional, and unmistakably manufactured, but with a sense of character and familiarity.

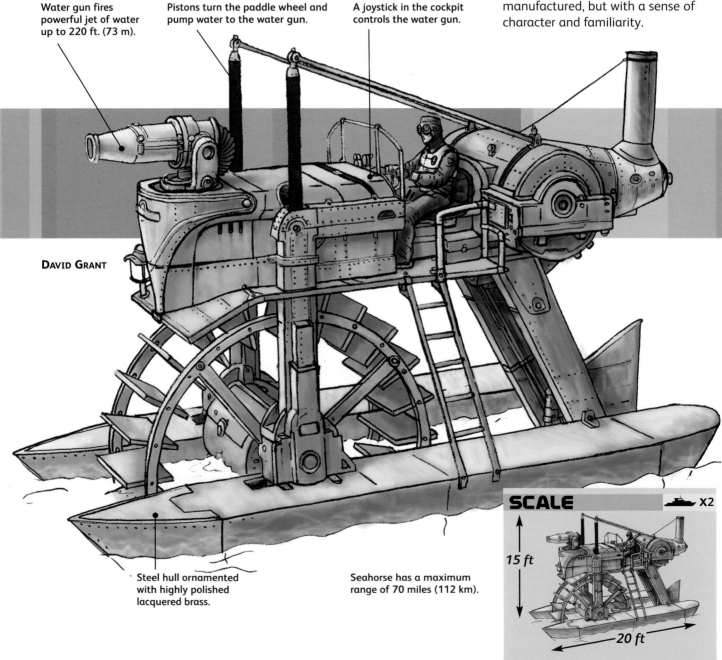

Water gun fires powerful jet of water up to 220 ft. (73 m).

Pistons turn the paddle wheel and pump water to the water gun.

A joystick in the cockpit controls the water gun.

DAVID GRANT

Steel hull ornamented with highly polished lacquered brass.

Seahorse has a maximum range of 70 miles (112 km).

SCALE

X2

15 ft

20 ft

Developing the design

A curved, creaturelike profile lends this otherwise angular and obviously manufactured vehicle a connection to its animal namesake.

Keep each board evenly spaced around the wheel's frame.

Maintain structural consistency in the paddle wheel to ensure it looks believable.

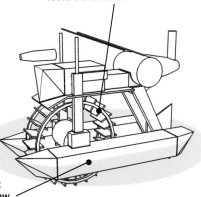

The water gun is placed on the front of the vehicle and given plenty of radial clearance for when it is in use.

The craft sits very high on the water; this view shows how little sits below the waterline.

Constructing the craft

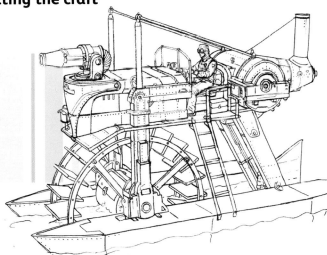

◄ Linework

1 Use a three-dimensional computer program to turn a concept sketch into a series of basic shapes. Print out a faint copy of the 3-D model and draw in lines with a fine mechanical pencil. Refer to the initial sketch so you keep a natural hand-drawn feel to the artwork.

► Coloring

3 To color, add another Multiply layer and use the Shading selection to add flat colors that complement each other. Next, add extra details, such as rust on the ironwork, and vary the colors to give a weathered feel. Finally, add an overlay to increase contrast and show variety in surface glossiness.

► Shading

2 Scan the linework into Photoshop and place a Multiply layer on top. Make a mask in 20 percent gray to use as a border for shading and for coloring. Work out the direction of light and use a medium brush to shade. Finally, use a small brush to add detail.

Water is an extra light source, giving off refracted light.

Cetaceans have long been used by military outfits and trained for mine clearance, reconnaissance, and even attack roles. However, their **willful**, individualistic personalities cause severe problems. Escapees are common and represent an expensive loss in resources and time. The J8 program has solved this issue with heavily **genetically modified** belugas, featuring post-growth mechanical grafting that fits them to be overseen by a human pilot.

Opened canopy exposes cockpit.

Feed tubes supply a space-efficient, dehydrated cocktail to nourish the remaining biological elements of the cyborg.

Synthetic fin extensions can unfurl or contract depending on the need for speed or maneuverability.

Design considerations
Using an enlarged beluga whale as framework, portions are added and cut out of its shape. The whale should be recognizable but almost obscured by the cold, compassionless technological modifications.

Manipulator arms can be controlled by the pilot for precise tasks, such as repairs and sabotage.

Legs mounted on the underbelly allow the cyborg to crawl along the sea bottom and minimize water disruption for the sake of covert movement.

KEITH THOMPSON

SCALE X1

25 ft

5 ft

Developing the design

The beluga's shape offers a smooth profile that leaves room to add elements without obscuring or removing necessary parts of the whale. The pectoral fins are not angled in a straight line with each other, but in a wide V-shape.

This structure shows the proportions of the original organic fins, and not their extensions.

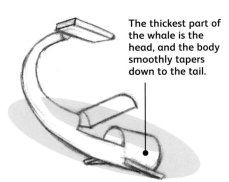

The thickest part of the whale is the head, and the body smoothly tapers down to the tail.

This cutout part is the opened hatch that exposes the cockpit.

Constructing the craft

◄ Linework

1 Make sure the ambient pencil texturing on the original beluga parts is distinct from the mechanical parts. This distinction has to be made in the earliest steps of the art and carried through to the finish.

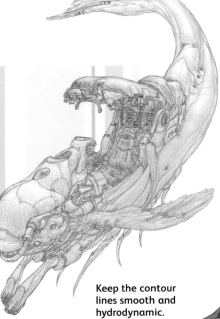

Keep the contour lines smooth and hydrodynamic.

► Shading

2 The recessed cockpit should be the darkest portion of the vehicle, but don't take the focal point of the design away from the eye of the creature.

An obvious differentiation between the organic and mechanical parts is made at this stage.

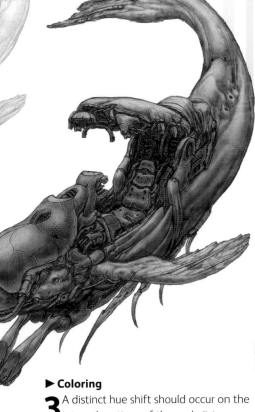

► Coloring

3 A distinct hue shift should occur on the internal portions of the cockpit to visually indicate that these parts are never intended to come in contact with the water, unlike the outer portions of the craft.

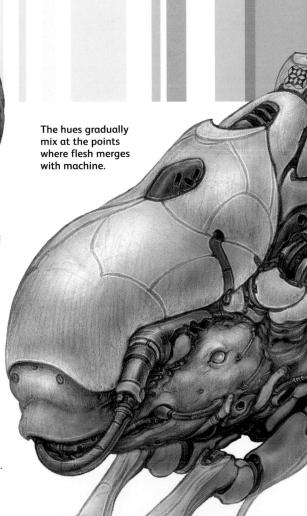

The hues gradually mix at the points where flesh merges with machine.

The design origins of the **supermaneuverable** Spy Bee are apparent in its lines, the bends of its fuselage, the vehicle's cowl, and the lattice radiator in the front: it could only be inspired by the **racecars** of the 1960s and '70s. The Bee's key feature is the two **powerful** propellers that extend from the cabin. They change position as the Bee flies, making for superb reaction time.

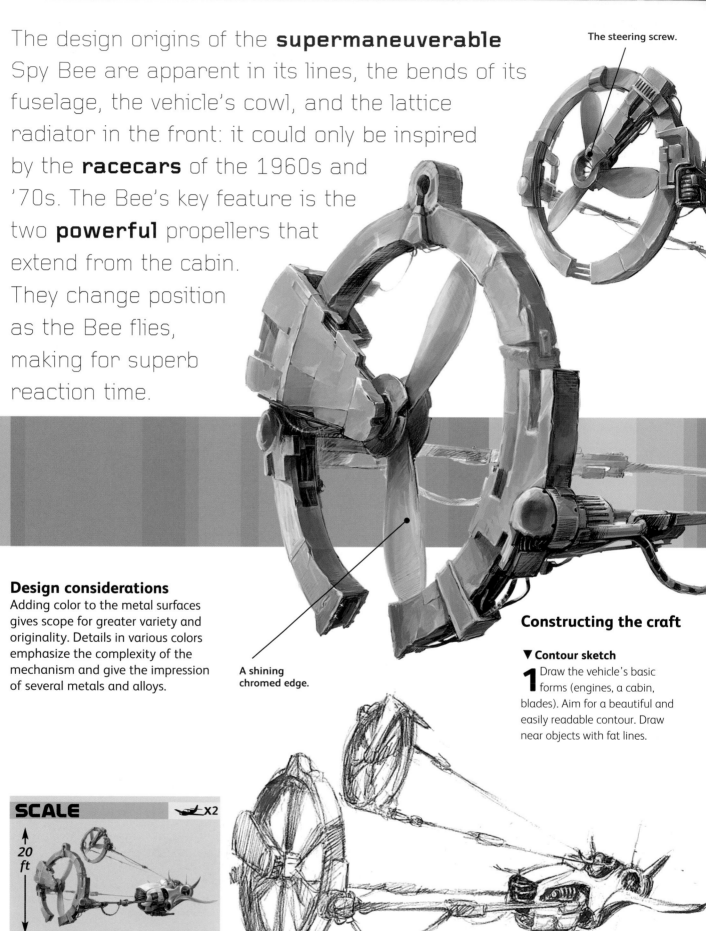

The steering screw.

A shining chromed edge.

Design considerations
Adding color to the metal surfaces gives scope for greater variety and originality. Details in various colors emphasize the complexity of the mechanism and give the impression of several metals and alloys.

Constructing the craft

▼ **Contour sketch**

1 Draw the vehicle's basic forms (engines, a cabin, blades). Aim for a beautiful and easily readable contour. Draw near objects with fat lines.

SCALE

X2

20 ft

60 ft

Developing the design

Split into three major parts, this vehicle had a carriage containing the pilot being pulled by two smaller masses connected to the carriage by dual lines.

This view favorably displays direction and principles of movement, featuring the pilot cabin and main engine.

The basic turbine changes position depending on how the Bee moves.

The wings also act as stabilizers and balance the fuselage.

Auxiliary turbines.

Engine movement is transferred to the main screw by means of a belt drive and cog wheels.

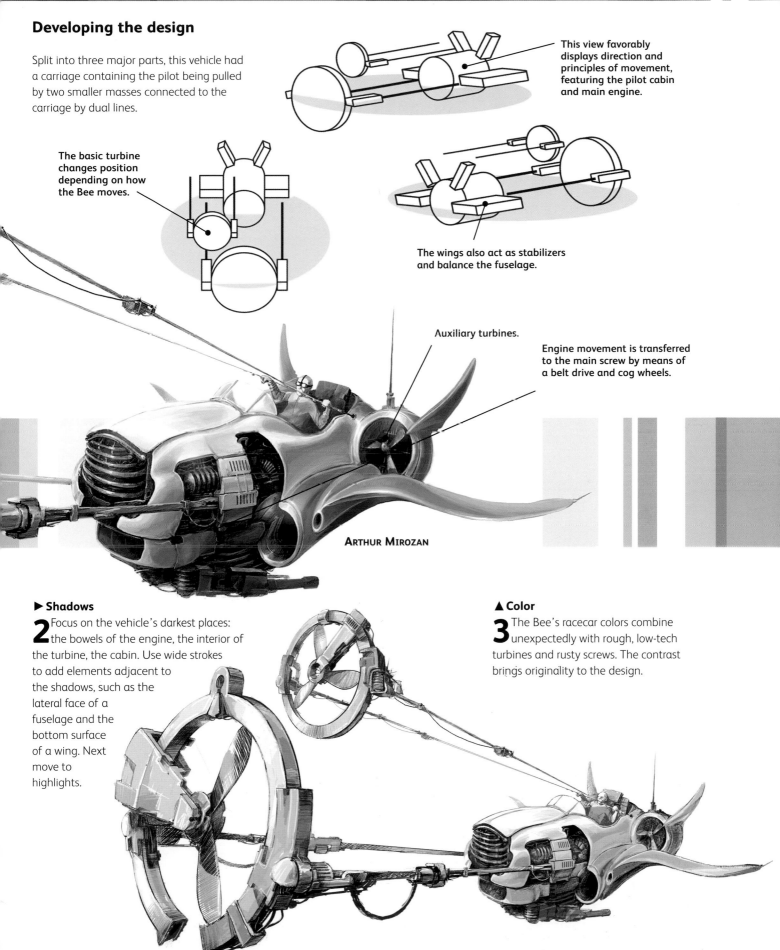

ARTHUR MIROZAN

► **Shadows**

2 Focus on the vehicle's darkest places: the bowels of the engine, the interior of the turbine, the cabin. Use wide strokes to add elements adjacent to the shadows, such as the lateral face of a fuselage and the bottom surface of a wing. Next move to highlights.

▲ **Color**

3 The Bee's racecar colors combine unexpectedly with rough, low-tech turbines and rusty screws. The contrast brings originality to the design.

Invented as a sort of mobile **guardpost**, the Steel Belly is used by colonial troops throughout the British Empire to protect and **barricade** embassies and trading posts during times of civil unrest. Plodding and ungainly, this vehicle is used as a visual deterrent as much as anything: **looming** industrial weaponry capable of mowing down whole crowds.

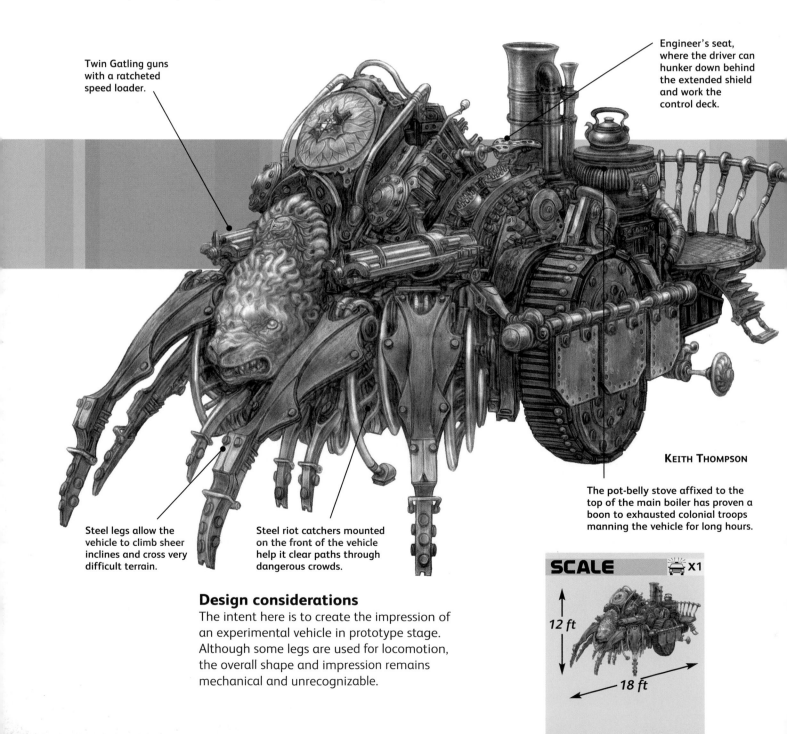

Twin Gatling guns with a ratcheted speed loader.

Engineer's seat, where the driver can hunker down behind the extended shield and work the control deck.

KEITH THOMPSON

The pot-belly stove affixed to the top of the main boiler has proven a boon to exhausted colonial troops manning the vehicle for long hours.

Steel legs allow the vehicle to climb sheer inclines and cross very difficult terrain.

Steel riot catchers mounted on the front of the vehicle help it clear paths through dangerous crowds.

Design considerations
The intent here is to create the impression of an experimental vehicle in prototype stage. Although some legs are used for locomotion, the overall shape and impression remains mechanical and unrecognizable.

SCALE X1

12 ft

18 ft

Developing the design

In the finished design, armored plates cover the ends of these cylinders. Leave plenty of room underneath the carriage of the vehicle for the leg mechanisms to function freely.

The legs do not bear a lot of weight but are used to drag the vehicle forward.

The railing and platform coming off the back of the craft must be level and match the plane of equilibrium.

The driver sits atop the slanting top cylinder, and additional crew can ride the rear platform.

Constructing the craft

▶ **Linework**

1 The crests on the front plates are embossed, so draw them in now rather than painting them in as decals in later steps.

Be sure all the wheels are closely aligned with each other, unless one set is mid-steering.

▼ **Shading**

2 Remember that this vehicle will have a large and obvious cast shadow below its carriage when placed in an environment.

Many parts of the vehicle are carefully polished and shined, but don't overdo it.

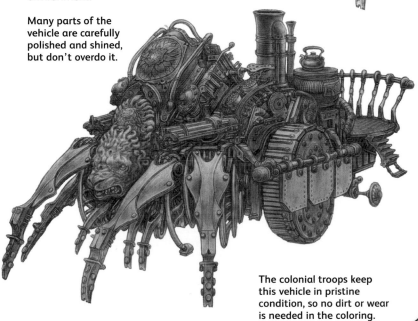

▶ **Coloring**

3 Although the vehicle is mostly the color of industrial metals, use plenty of rich gilding and embossed decoration to add an additional variety of hues.

The colonial troops keep this vehicle in pristine condition, so no dirt or wear is needed in the coloring.

88 SNUBNOSE FIGHTER

An immensely loud double **boom** is usually the only indication to survivors that they have just lived through a bombing raid from Snubnose **fighters**. These ground-attack aircraft are often used on the forefront of land and sea invasions and have become so heavily employed among **warring nations** that pilots refer to encounters with other Snubnoses as "staring into the mirror."

CONCEPT SKETCH

- *Military*
- *Brutish* • *Drab*

Small wings stabilize the craft and can fold down for tightly packed storage on carriers.

The tinted canopy prevents enemy pilots from gauging whether they are dealing with a living pilot or with a less cunning autopilot.

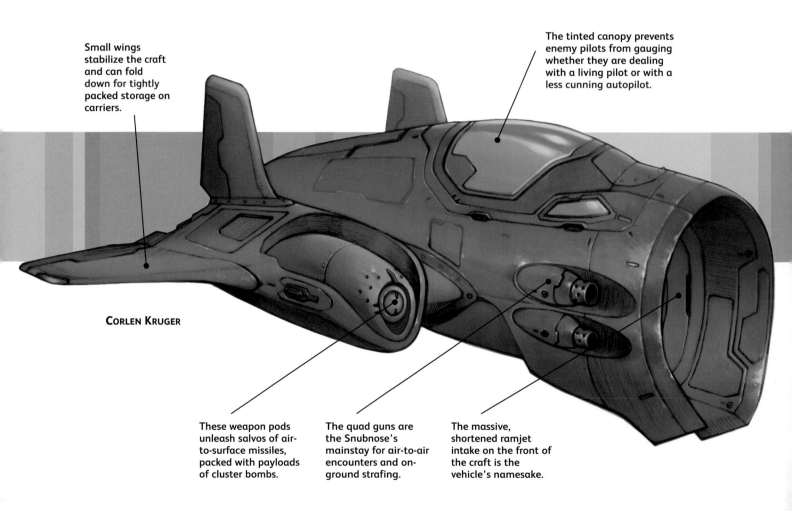

CORLEN KRUGER

These weapon pods unleash salvos of air-to-surface missiles, packed with payloads of cluster bombs.

The quad guns are the Snubnose's mainstay for air-to-air encounters and on-ground strafing.

The massive, shortened ramjet intake on the front of the craft is the vehicle's namesake.

Design considerations

This is a futuristic plane with elements of a WWII fighter plane as its foundation, so the color scheme needed to have some basis in history. Wear and tear in the form of scratch marks add necessary character.

SCALE

 X1

10 ft

30 ft

Developing the design

It was key that the hollow in the nose of the fighter appear to funnel through to the rear nozzle. An aerodynamic curve and taper carry horizontally through the structure.

This is constructed in the same manner as a traditional aircraft.

Smooth shapes give the vehicle an aerodynamic appearance.

The vehicle's shape complements its function.

Constructing the craft

▶ Linework

1 A front-side angle is the best for showing off the unique nose of this plane. Begin with basic shapes and set your design before you dress it up with detail.

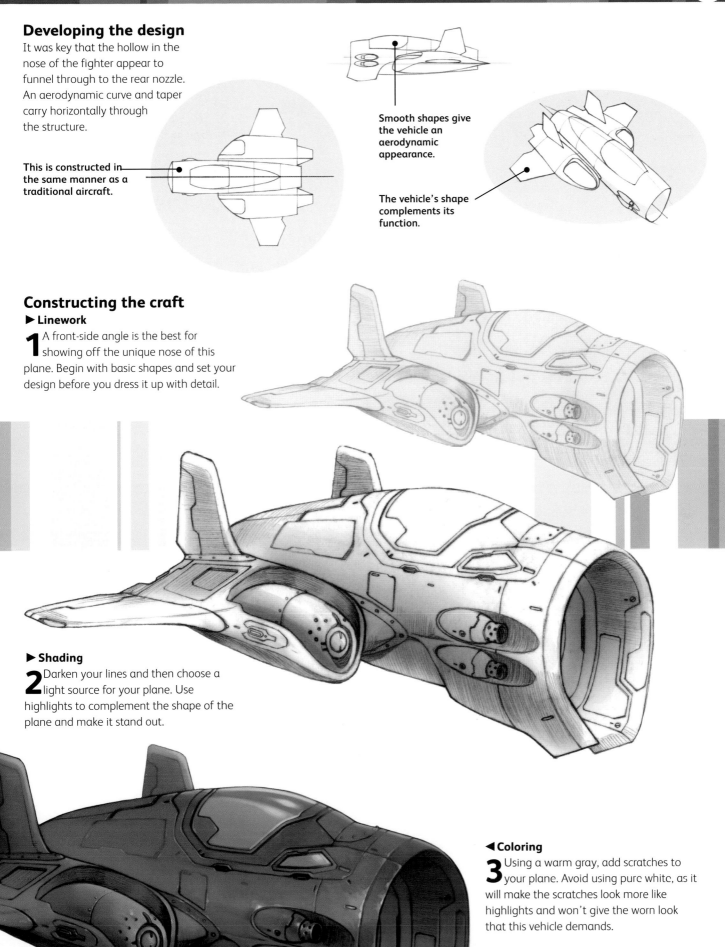

▶ Shading

2 Darken your lines and then choose a light source for your plane. Use highlights to complement the shape of the plane and make it stand out.

◀ Coloring

3 Using a warm gray, add scratches to your plane. Avoid using pure white, as it will make the scratches look more like highlights and won't give the worn look that this vehicle demands.

When a treaty was signed by the dominant empires to end the use of freebooters in maritime affairs, an open season was declared on **pirates**, with bounties for their ears being offered at all major trading ports. This drove the pirates underground, so to speak, and to use the structures of **gargantuan**, extinct **crustaceans** as their new ships of fortune, pulling merchant vessels below the waves to tear their hulls asunder and reap the rewards.

Ballast mines tied to adjustable rigging can suddenly be let up into a ship's hull floating above.

The Jolly Roger emblazoned on the upper carapace instills fear in any crew witnessing the Shellfish approach from the shallows.

Crow's-nest eyes, for crew members on lookout.

Portholes abound in the Shellfish's carapace, used to view the surroundings from every possible angle.

KEITH THOMPSON

Large storage-bay doors open so the claws can stuff captured cargo into the ample storage holds.

Massive iron-reinforced claws pull the wreckage of blasted ships into the water's depths and split open their cargo holds.

Design considerations

This design deals with the idea of using huge animals, rather than plant matter, as a building material for a vehicle. Instead of the creature being harnessed and craft parts mounted on or added to the base, the Corsair Shellfish has been hollowed out, its exoskeleton used as an outlying structural base.

SCALE ⚓ X1

120 ft

130 ft

Developing the design

The claws are held forward and have a sizable berth between them and the legs to ensure their movement is unimpeded.

The claws are much larger than any of the other limbs but have the same number of joints.

The body of the crab is not circular but ovoid: longer in girth than length.

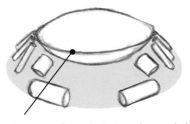

The curve of the shell gives the portholes set in it a wide range of vision.

The legs are laid out in a curve that matches the circumference of the craft's body.

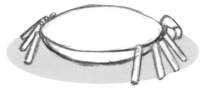

As with real brachyura, this creature has five visible pairs of limbs (including claws).

Constructing the craft

▶ Linework

1 Use the viewing windows lining the shell to indicate the scale of the craft. Everything else is visually keyed into this dictated scale.

The rough surface of the crab shell has a distinctively lumpy profile.

The manufactured additions to the crab, such as the pirate insignia and metal plates, can be flashily painted and decorated with brazen patterns and hues.

▼ Shading

2 This craft spends almost all of its time on the sea bottom, so include plenty of rough texturing for the shell's battered and barnacle-encrusted surface.

Do not darken the shell to the point where the shadows of the portholes become obscured.

◀ Coloring

3 A crab provides a wide range of hues to choose from, and developing your own color scheme to use on it will not look too unnatural.

Although the front section is quite complex, it can be structurally contained well in a single box.

The front section may have more volume, but the rear wings extend out farther.

The rear view shows the sloping profile of the section where the wings join.

FUTURE FORTRESS

From all angles

When dealing with the structural basis of a craft such as this, the artist must take care with the varying angles of projecting wings and keep them aligned consistently—both with the main body of the craft and with each other.

Technology only hinted at today ushers in an age of super vehicles capable of incredible speeds and achievements. These craft pioneer new frontiers of travel, their complex and sophisticated design arising out of centuries of technological development.

These engines are identical; being standardized they could be interchanged, and are easily and quickly serviced.

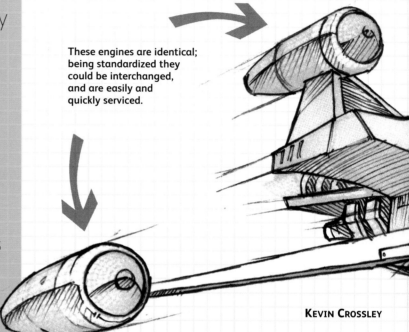

KEVIN CROSSLEY

CRAFT OF TOMORROW

Developing ideas

Although the craft had to be futuristic, it was to retain elements recognizable to the viewer. This would give the craft a grounding; an impression that it was developed from technology recognizable today.

► The first design had no engines on the wings and a more angular canopy.

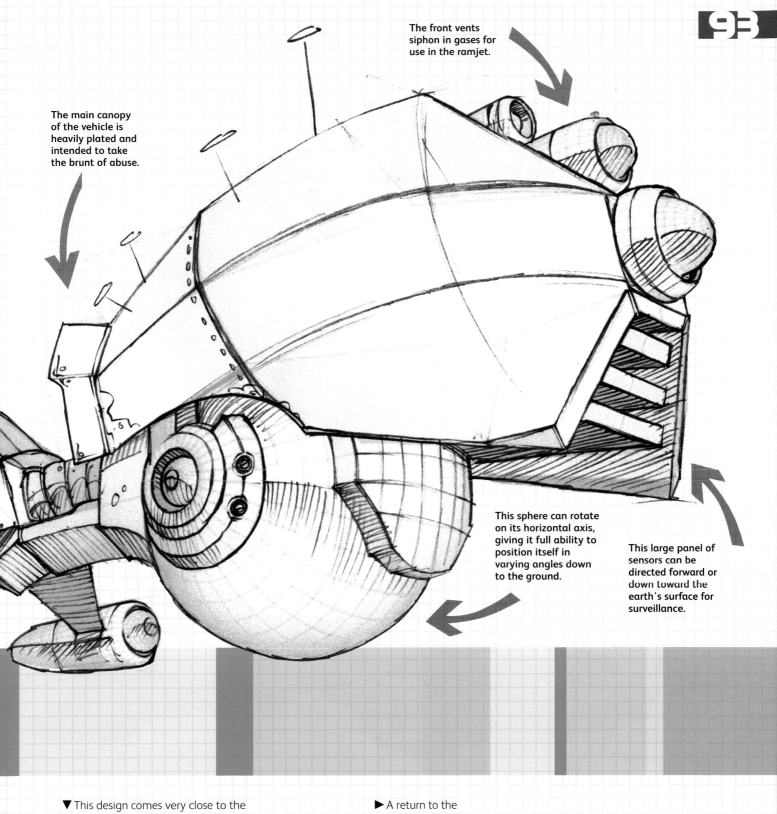

The front vents siphon in gases for use in the ramjet.

The main canopy of the vehicle is heavily plated and intended to take the brunt of abuse.

This sphere can rotate on its horizontal axis, giving it full ability to position itself in varying angles down to the ground.

This large panel of sensors can be directed forward or down toward the earth's surface for surveillance.

▼ This design comes very close to the final one and simply lacks the cluster of projections in the upper canopy.

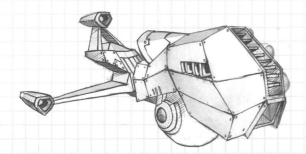

► A return to the angular canopy and complete removal of the rear wings created an interesting profile but lost the impression of a vehicle capable of high speeds.

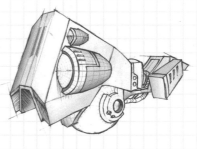

The age of tank brigades **storming** across fields and deserts is over, ended by a glut of inexpensively equipped antitank soldiers and **devastatingly precise** attack helicopters. However, the tank still has its place protecting convoys and providing highly mobile **artillery** batteries. The T10 Charioteer, a design anonymously donated to the United Nations to aid in global conflicts, has revitalized the proficiency of mechanized divisions.

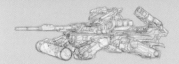

CONCEPT SKETCH

- Armored • Mechanical
- Attack vehicle

Helmsman robotic torso, commanded by a direct link to either the gunner or driver, gives the crewmen the impression of riding atop a vehicle completely under their control.

Additional boxes of reactive armor mounted on top of the tank's normal protection.

160 mm point-of-fire howitzer.

Fully automatic-loading 130 mm gun with a variety of task-specific rounds available.

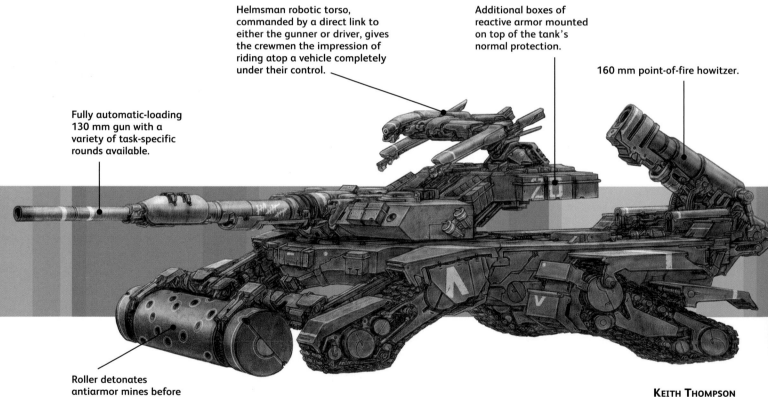

Roller detonates antiarmor mines before they are positioned under vulnerable components of the tank.

KEITH THOMPSON

Design considerations
This design, set in the near future, takes a conventional modern tank as a basis and attempts to evolve it. The basic chassis and turret remain conventional so that other design elements sit on a recognizable base.

SCALE 🚌 x1

18 ft

42 ft

Developing the design

The turret has almost the complete 360 degrees of rotational movement. The rear gun seen in the finished art can retract into the main carriage, as can the Helmsman robot.

The chassis has quite a bit of ground clearance in this pose, although the tank can squat for increased cover.

The four treaded legs, if flattened out to lower the tank carriage to the ground, would be the same thickness as the carriage of the tank.

The track's pivots are positioned centrally to the heaviest point of the tank: just under the turret.

The roller has to be as wide as the edge of the treads; otherwise, it will let mines get by.

The turret is positioned at the front of the tank chassis.

Constructing the craft

▶ Linework

1 Textural linework is not widely used on this design because the craft is made primarily of high-precision synthetics with relatively smooth surfaces.

Sharp, angular linework gives this design a modern and militaristic feel.

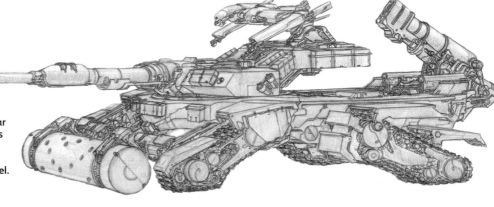

Because the craft is cold and utilitarian, be sure that it appears heavy, tough, and imposing.

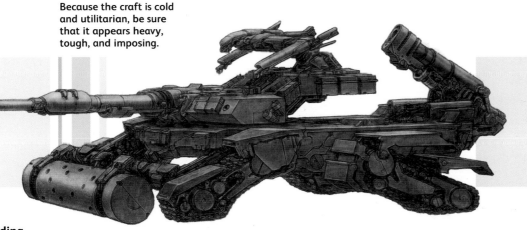

▲ Shading

2 A lot of angular, sharp planes present a series of obvious and geometric value shifts. Add slight highlights to the sharp edges of shapes.

Do not be afraid to splash around the color, but keep it subdued and somewhat drab.

▼ Coloring

3 Although it would make perfect sense to paint the tank with a camouflage pattern, it is visually not a great idea. Camouflage is designed to break up shapes and make an object difficult to read, a counterproductive effect when used in artwork. However, a strategically faded and suppressed pattern could definitely be used.

Beneath the **ice** of the moon Europa, this colorful Fish Sub, from the Weisstaur colony, adds sparkle to the ocean's **dark depths**. The people of Weisstaur are highly protective of their **isolationist** lifestyle, yet generous hosts to occasional visitors.

CONCEPT SKETCH

- Ichthyic basis
- Series of fins
- Single crew member

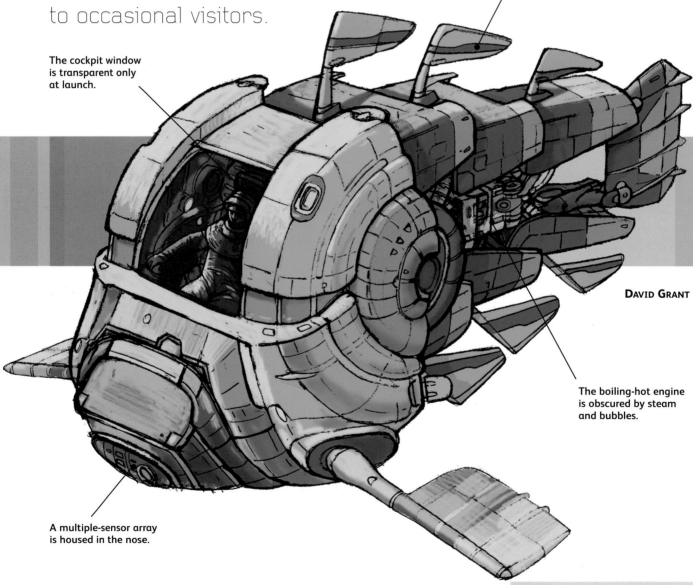

The many fins give the sub great maneuverability.

The cockpit window is transparent only at launch.

DAVID GRANT

The boiling-hot engine is obscured by steam and bubbles.

A multiple-sensor array is housed in the nose.

Design considerations

This vehicle's design is inspired by fish physiology and accomplished through sophisticated technology. The craft is small and driven by a single pilot, so agility and maneuverability are key features and must be apparent in the dexterous and multijointed structure.

SCALE

X1

15 ft

20 ft

Developing the design

The front portion of the craft is predominantly the cockpit, with key mechanical parts trailing back in the segmented tail portions. The circular element extends over the connection point between the large, first segment and the next one.

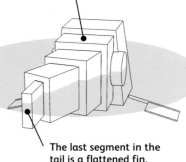

A top and bottom fin will extend from each of the three rear tail segments.

The pectoral fins extend out from the front base of the craft.

The engine will be housed in the middle of the three rear segments.

The last segment in the tail is a flattened fin.

Constructing the craft

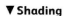

▶ Linework

1 Print out a faint copy of the three-dimensional model and draw in the linework using a fine mechanical pencil. Keep referring to the initial sketch so that the image can look as natural as hand-drawn artwork with the accuracy of a computer rendering.

▼ Shading

2 Scan the finished linework into Photoshop and place a Multiply layer on top. In this layer you can make a complete mask of the vehicle in a 20 percent gray. This can be utilized afterward as a border for shading and then for coloring. Work out where the light is coming from so that highlights and shadow give depth and believability to the vehicle. Select a medium brush to shade.

The lighting inside the cockpit will be independently sourced and artificial.

The paneling on the hull plays such an important decorative role that it is included during the linework stage.

▶ Coloring

3 Add another Multiply layer and use the Shading selection to choose flat colors that work well together. Finally, use an Overlay layer to give more luster and gloss to the vehicle.

An eye-catching hue in the cockpit brings the viewer's attention to the pilot.

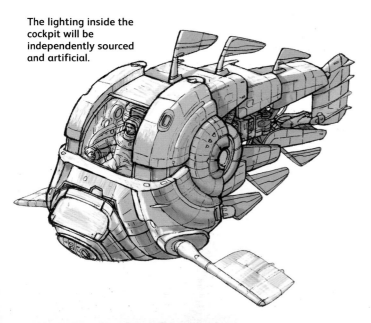

During expansive **military** sweeps across Europe and Asia, the GMSSR needed a vehicle that could be used by small, two-man crews, allowing them full mobility as they patrolled freshly **shelled** cities. Rugged and dependable, these suppressive Cossack Motorcycles carve vicious paths through the **refugee-strewn** streets of shattered capitals, engaging anyone their crews view as insurgents.

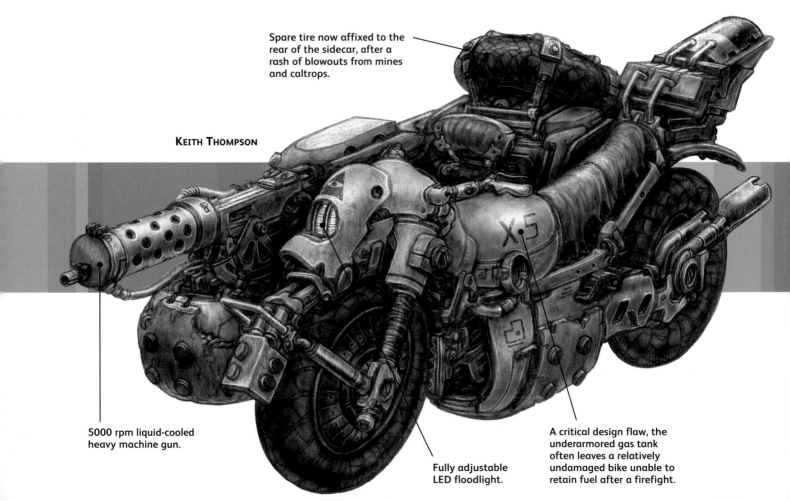

KEITH THOMPSON

Spare tire now affixed to the rear of the sidecar, after a rash of blowouts from mines and caltrops.

5000 rpm liquid-cooled heavy machine gun.

Fully adjustable LED floodlight.

A critical design flaw, the underarmored gas tank often leaves a relatively undamaged bike unable to retain fuel after a firefight.

The bike is turbine powered and capable of over 375 hp and 550 ft/lb of torque.

Design considerations
Although the design constitutes a different take on relatively preexisting technologies, a clunky, industrial feel is exaggerated throughout, from the throwback gun to the large studs coating thick plates of metal.

SCALE ![car]X1

4 ft

7 ft

Developing the design

The two wheels on the bike must line up perfectly, whereas the sidecar has more room for play in a slightly looser attachment to the bike. The sidecar's wheel is positioned rather far to the rear, giving the whole vehicle a contact with the ground similar to that of a tricycle.

The gun is centered in the sidecar so its occupant can comfortably use it with both hands.

All the wheels are identical in size and shape (so the spare works on any flat).

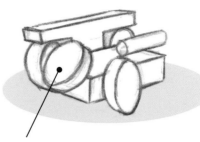

This angle better shows how the spare tire is fixed at a slant to the back of the sidecar.

Constructing the craft

Use a lot of ambient pencil texturing to depict the well-worn and beaten surfaces.

Ensure that the shading does not cover up the heavy texturing of the bike's materials.

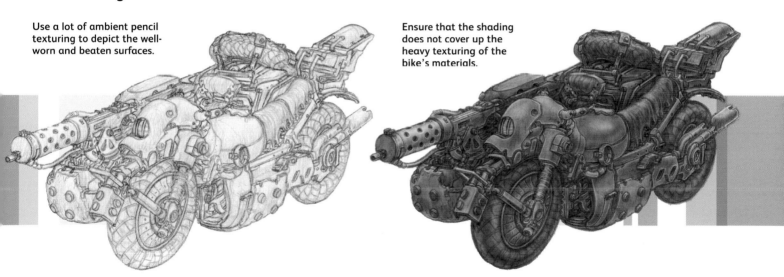

▲ Linework

1 Although the artist can arrange utilitarian elements (like the piping and studs) in a visually pleasing manner, it is important on designs such as these not to indicate conceptual decorations that would ruin the storytelling of the piece.

▲ Shading

2 Remember that certain elements, such as the rubber tires, reflect light differently from the more polished and reflective metals on other sections of the bike. The more delicate parts, such as the handlebars and gun, are likely to be cleaner and more polished.

► Coloring

3 This bike has been through a lot, and its crew does not have time to work on it beyond keeping it functioning properly. Therefore, if a section of the bike is painted, ensure that parts of it are either chipping off or covered in dirt.

Keep the colors aesthetically pleasing, but be sure they still convey the impression of a drab vehicle used by a violent and oppressive military system.

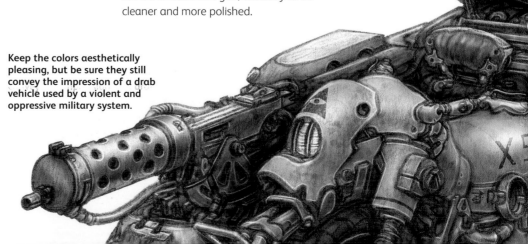

For many years this **vast** flying city had been a highly visible landmark over the mining colony at Azoth. Twenty years ago it **disappeared**. Many believe the mineworkers rebelled against the draconian workload they endured under their governors and **seized control**. How it has stayed hidden is a great mystery.

CONCEPT SKETCH

- *Block of buildings*
- *Vast scale*
- *Ponderous movement*

Design considerations

Being a city, it is important to give this structure a sense of scale. The inclusion of tiny windows gives it a real feeling of vastness, and plenty of tiny elements of architectural detail add to the illusion that this is an airborne metropolis. This craft is essentially modular and industrial, but with personal modifications.

The vast harmonic blocks permanently hold the city in the sky without the need of a power source.

The "roof" of each tower provides a light source for the work force inside.

The ornate middle tier belongs to the religious and pious clerk caste. They deal with administration and medical work.

The vents and flumes housing the harmonic blocks dampen the vibrations, thus stopping the city being torn apart by resonance.

Each tower is modified by the ruling governor to reflect his success.

Clusters of engines move the city from its stationary position.

Corner prongs house the communication centers and shield generators.

DAVID GRANT

Each tower from top to bottom (excluding the longer corner towers) is 3 miles (5 km) high.

Large external docking bay for the enormous cargo ships used for shipping ore.

SCALE

X8

900 ft

1900 ft

Developing the design

A repetitive network of buildings forms the dominant part of the vehicle, with the propulsion systems lying underneath the main structure. The rectangular shape lends the vehicle an implied direction of movement (toward the thinner ends). Carefully measured spacing and proportion, coupled with scale, give this vehicle an architectural feeling.

At this scale, aerodynamic concerns are dismissed.

This view matches the final art. Compare the two to see the vehicle's structural basis.

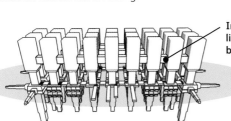

Interconnecting bridges link up at differing heights between buildings.

Constructing the craft

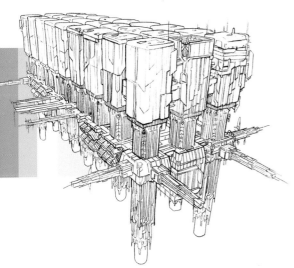

◄ Sketching

1 Draw a few simple ideas on the same page and pick out the strongest; then, fine tune this idea until you come up with a more detailed, but still sketchy, plan. Build up the basic shapes that define the vehicle by using a three-dimensional computer program to make sure you have the perspective correct, and to ensure that nothing is too illogical in the vehicle's construction.

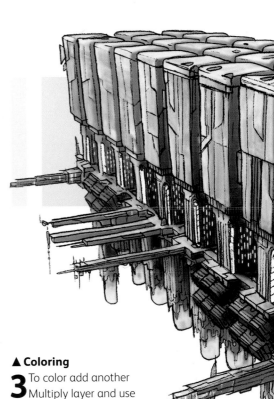

► Shading

2 Scan the finished linework into Photoshop and place a Multiply layer on top. In this layer you can make a complete mask of the vehicle in a 20 percent gray, which can afterward be utilized as a border for shading and for coloring. Select a medium brush to shade, and consider your light source, because accurate rendering of light and shadow will really add to the believability of the vehicle. Use a smallish brush to produce the "bitty" surface that helps to give a sense of scale.

▲ Coloring

3 To color add another Multiply layer and use the Shading selection to add flat colors that work together. Use Gradient fills on top of these to give depth, making the back towers paler than the near towers. With an Overlay layer you can pick out highlights, clarify the direction of the light source, and ascertain the materials used in the craft, whether they are metallic or stone, shiny or dull.

A further step taken in the **nuclear** arms race has seen Boomer-class submarines split, unfurl **legs**, and climb from the sea onto land like an evolving creature. Manned by huge numbers of crew and featuring technology funded like no other enterprise in history, these delivery systems of **world-ending** power are matched only by their counterparts, hanging in orbit above the heads of a fearful world.

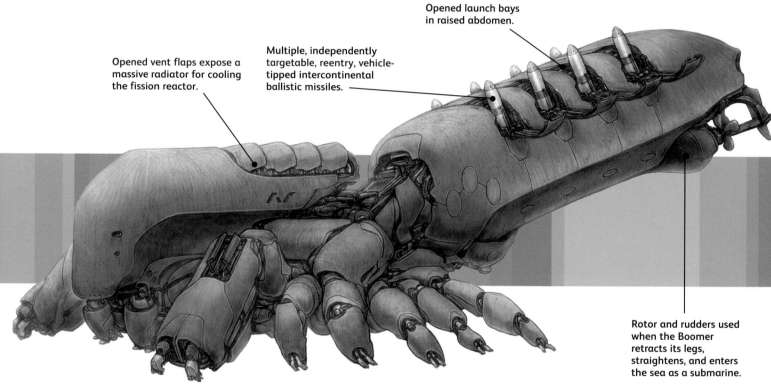

Opened launch bays in raised abdomen.

Opened vent flaps expose a massive radiator for cooling the fission reactor.

Multiple, independently targetable, reentry, vehicle-tipped intercontinental ballistic missiles.

Rotor and rudders used when the Boomer retracts its legs, straightens, and enters the sea as a submarine.

KEITH THOMPSON

Incredibly thick armoring ensures that the Boomer can withstand any bombing or bombardment long enough to let loose its hellish salvo.

Design considerations

Conveying a massive scale is a primary concern and subtly affects every part of the art. Although an insect inspiration is obviously used, it more closely resembles a microscopic mite for the sake of less recognizable proportioning.

SCALE X1

105 ft

220 ft

Developing the design

The large front legs are used to pull the huge mass from the water and drag the vehicle forward, while the smaller legs are primarily for support.

A vehicle this huge needs a large base of contact with the ground for stability.

The front body cylinder isn't as wide as the rear cylinder: the legs retract up to fill in this width when it turns into a submarine.

The whole set of smaller legs angles backward to hold the weight of the huge, raised abdomen.

Constructing the craft

▼ Linework

1 The scale of this vehicle is so large that it is necessary to keep the linework thin, delicate, and sometimes fading off.

Ambient pencil texturing is careful and slight, showing an approximated texture over a large surface area.

▼ Shading

2 When adding textures, keep them small and intricate to convey size. Unless there is an obvious reason for a large marking on the craft's surface, try to avoid creating one.

A less-contrasted shading effect is necessary on a piece that features obvious atmospheric perspective.

Fade off the hue saturation on parts of the vehicle located further in the distance.

▼ Coloring

3 Atmospheric perspective and scale cause the colors to be quite subdued. Do not play with too many bright highlights or sharp hue shifts on a vehicle this huge.

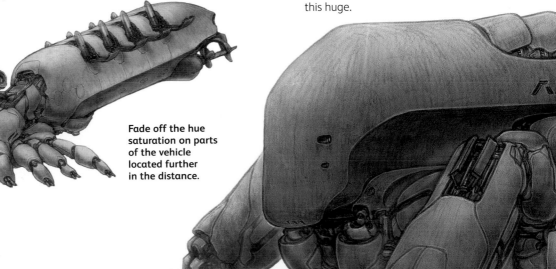

Highly **corrosive** chemicals, used in the late twenty-second century's Scourge Wars, created wastelands hostile to life. As cities recover, wealthy **thrill-seekers** explore the Scourge lands in armored off-road vehicles, such as the Fluxia Zhest XL. XL is pricey, but with standard **titanium** body shell and intelligent self-repairing wheels, it's the best choice—if you want to return alive.

CONCEPT SKETCH

- Rugged
- High-powered
- Two-seater

Design considerations

This vehicle must deal with treacherous off-road conditions and attack from hostile creatures, so it should look sturdy and dependable. To convey style as well as functionality, this utilitarian design is balanced by the use of dynamic lines and perspective.

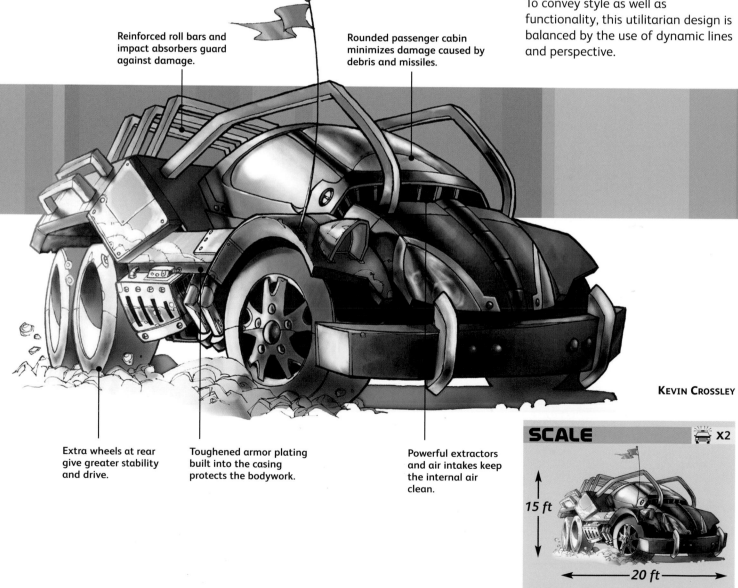

Reinforced roll bars and impact absorbers guard against damage.

Rounded passenger cabin minimizes damage caused by debris and missiles.

Extra wheels at rear give greater stability and drive.

Toughened armor plating built into the casing protects the bodywork.

Powerful extractors and air intakes keep the internal air clean.

KEVIN CROSSLEY

SCALE

X2

15 ft

20 ft

Developing the design

Selective distortion of shapes suggests windshield angle and vehicle orientation. Develop extra detail in later stages of the design. Note that the four rear wheels are still aligned with the front pair.

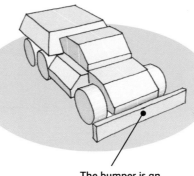

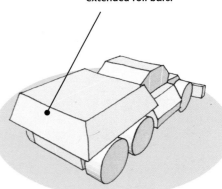

The rear will end up with many extended roll bars.

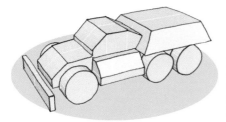

Here the car appears more trucklike and utilitarian than in the final art.

The bumper is an important and oversized part of the finished vehicle.

Constructing the craft

▶ Finished linework

1 Use this loose blue-pencil drawing as a guide for inking. Do this freehand to give a more robust, battered feel to the vehicle. Double up the line in places and add "random" marks, spots, and linework to break up the surface texture and add visual interest.

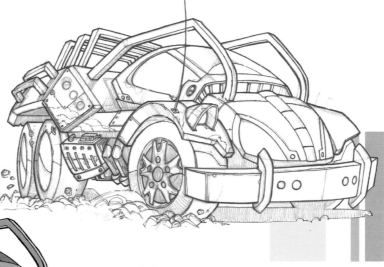

◀ Shading

2 Before deciding on the color scheme, determine the light source and shadow fall using a basic color palette. Use the Burn and Dodge tools in Photoshop to create dark and light tones, and use selective Gradient fills for dramatic shading variation.

▶ Coloring

3 Use the Lasso tool in Photoshop to select specific areas and adjust the color using the Color Balance menu. Fine tune each aspect of the vehicle's coloring until the balance is correct. Add appropriate highlights as a finishing touch.

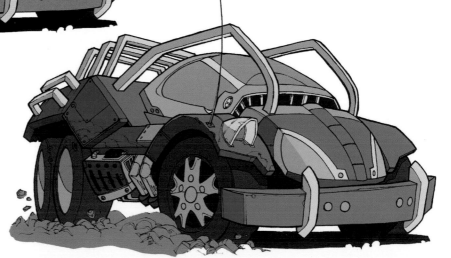

Reports have begun to surface in the Eastern Wars of an unidentified "flying tank" cutting **blazing swathes** through the armored divisions of both sides of the conflict. Speculation is that, whereas it is possible that both sides are testing the same **classified** hardware, it seems more likely that a major military contractor is using the war as a testing ground for new vehicles and weaponry.

Twin proprotors share a complicated gearbox that allows the blades to safely intersect when spinning.

Ammunition drum intersects tail fuselage and can be replaced quickly during refueling.

KEITH THOMPSON

Socketed 40 mm guns can be used to engage both ground and air targets.

Extended landing gear can be individually adjusted and angled to allow the gunship to land on extremely precarious terrain.

Socketed 60 mm belt-fed gun is used to saturate large areas of ground surface, targeting both armor and buildings.

Design considerations

Real attack helicopters have been used for inspiration in this design. Speculative technological advancements have been incorporated and an exaggerated armor plating used to give the vehicle its own distinct profile and appearance.

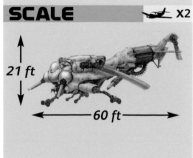

SCALE ✈ X2

21 ft

60 ft

Developing the design

The main fore body of the gunship is the largest section of the vehicle's structure so that it has room to carry troops and equipment into drop zones. Balance is extremely important on a helicopter, so ensure that it is perfectly bilaterally symmetrical.

The landing legs would be retracted during flight.

On most aircraft the top of the tail is the highest point of the vehicle.

The three main landing legs extend from the body of the craft in a triangle formation.

Constructing the craft

▶ Linework

1 Tighten up the linework as much as you can for this precision machinery.

Do not lay the line down too heavily on the paneling and rivet work.

▼ Shading

2 Remember that the gunship should not be too dark, lest it stand out too much as a silhouette in the sky.

Add slender highlights to the edges of the paneling that crisscross the armor plating of the helicopter.

▶ Coloring

3 Make sure the exposed mechanical parts differ in value and hue from the armor plating, which is made of a different, painted metal.

Use drab, militaristic hues on this design.

This small, one-seat vehicle is a very useful exploring unit for **scientists** who seek to discover the **secrets** of newly formed jungles. The animal-like design is intended to merge with the forest, making it easier to approach **wildlife**. Climbing up trees, rocks, or any other difficult land features is easier in this vehicle.

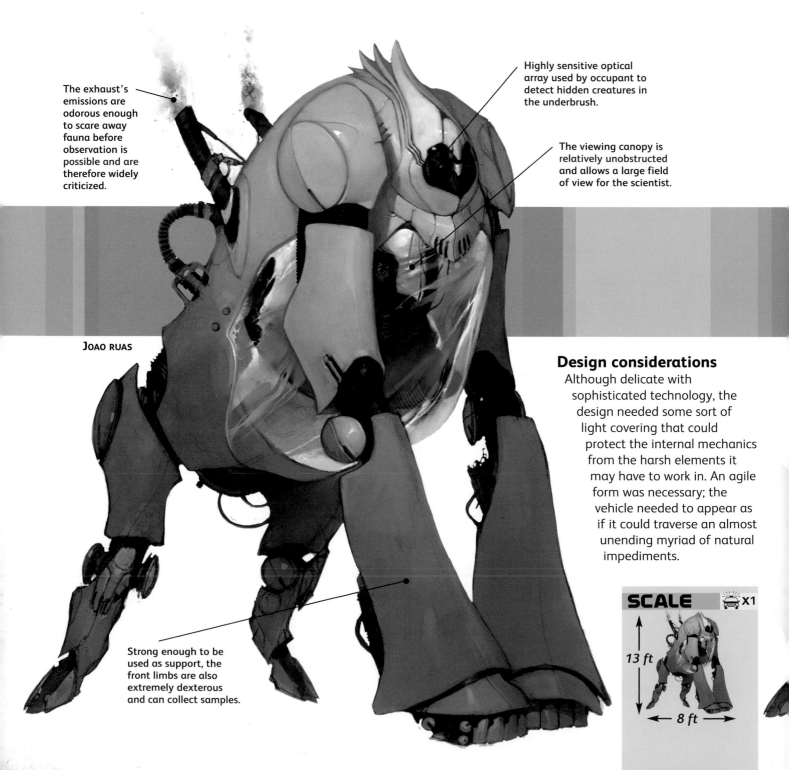

The exhaust's emissions are odorous enough to scare away fauna before observation is possible and are therefore widely criticized.

Highly sensitive optical array used by occupant to detect hidden creatures in the underbrush.

The viewing canopy is relatively unobstructed and allows a large field of view for the scientist.

JOAO RUAS

Design considerations

Although delicate with sophisticated technology, the design needed some sort of light covering that could protect the internal mechanics from the harsh elements it may have to work in. An agile form was necessary; the vehicle needed to appear as if it could traverse an almost unending myriad of natural impediments.

Strong enough to be used as support, the front limbs are also extremely dexterous and can collect samples.

SCALE ⚡X1

13 ft

8 ft

Developing the design

The distinct barrel body works with the apelike impression of the vehicle. The small button head is really just a canopy for sensors and is subdued and sunken into the torso. The body also houses the occupant and allows a reasonable amount of space for him or her to move in while seated.

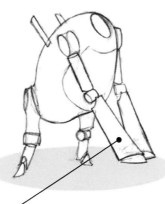

The basic shapes are ovals and cylinders.

The vehicle's arms need to be strong, similar to a gorilla's, to hold its weight.

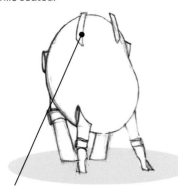

The exhaust pipes give a "real" feeling to the technology and fill up a boring area.

Constructing the craft

▶ Sketch

1 The design is at the same time "chunky," since the vehicle walks on difficult terrain, and sleek, to make it look advanced and futuristic.

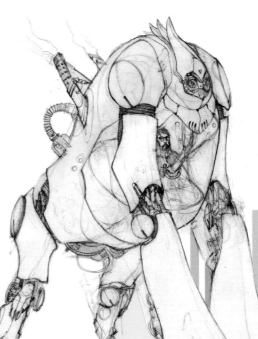

◀ Values

2 This stage defines which parts of the vehicle are going to be bright and which are going to be dark. Also decide which kind of material forms each surface.

▶ Colors

3 The nature of this vehicle is peaceful, and this should show in its colors. It's really important to try different combinations when working with a wide range of colors to find an interesting and tasteful palette.

Play with Textures to make smoke. It's easier and faster than painting it by hand.

Leave sketchy lines in some parts to make the painting less digital looking and more interesting.

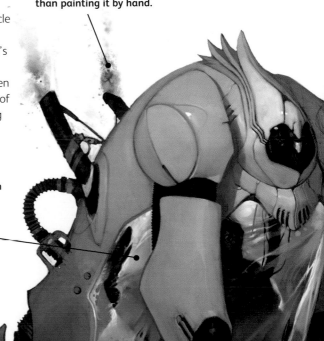

Used purely in a **defensive** role, these Interceptors are scrambled during times of **national emergency** or are commissioned for base defense. When an aerospace defense command alert is sounded, these craft are able to take off vertically, needing **no runway** or preparation time, and many are fitted to function with no pilot if necessary.

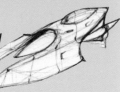
Design considerations

The Interceptor needed to have an almost simple, overly practical appearance, forgoing elaborate flourishes for a tried and tested factory-line design. The viewer had to be able to imagine swarms of these crafts speeding out together to take down incoming threats.

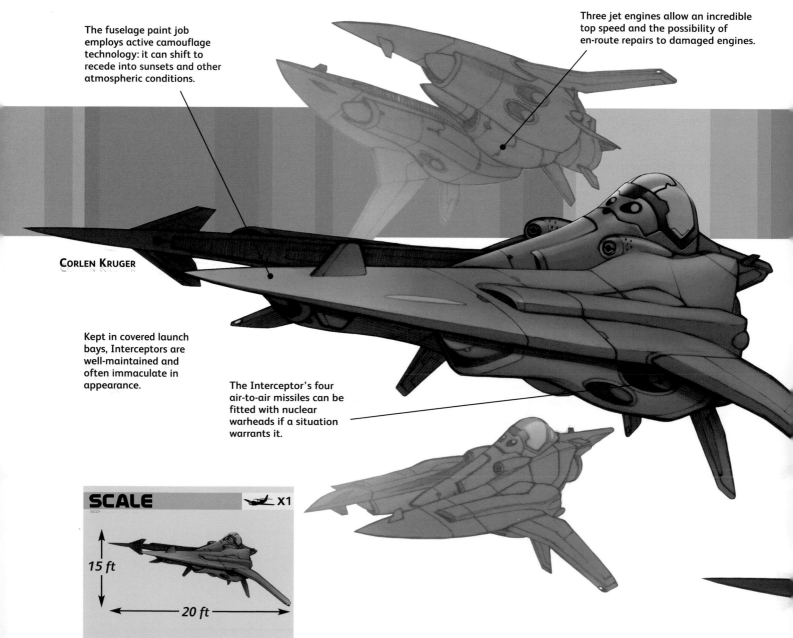

The fuselage paint job employs active camouflage technology: it can shift to recede into sunsets and other atmospheric conditions.

Three jet engines allow an incredible top speed and the possibility of en-route repairs to damaged engines.

CORLEN KRUGER

Kept in covered launch bays, Interceptors are well-maintained and often immaculate in appearance.

The Interceptor's four air-to-air missiles can be fitted with nuclear warheads if a situation warrants it.

SCALE ✈ X1

15 ft

20 ft

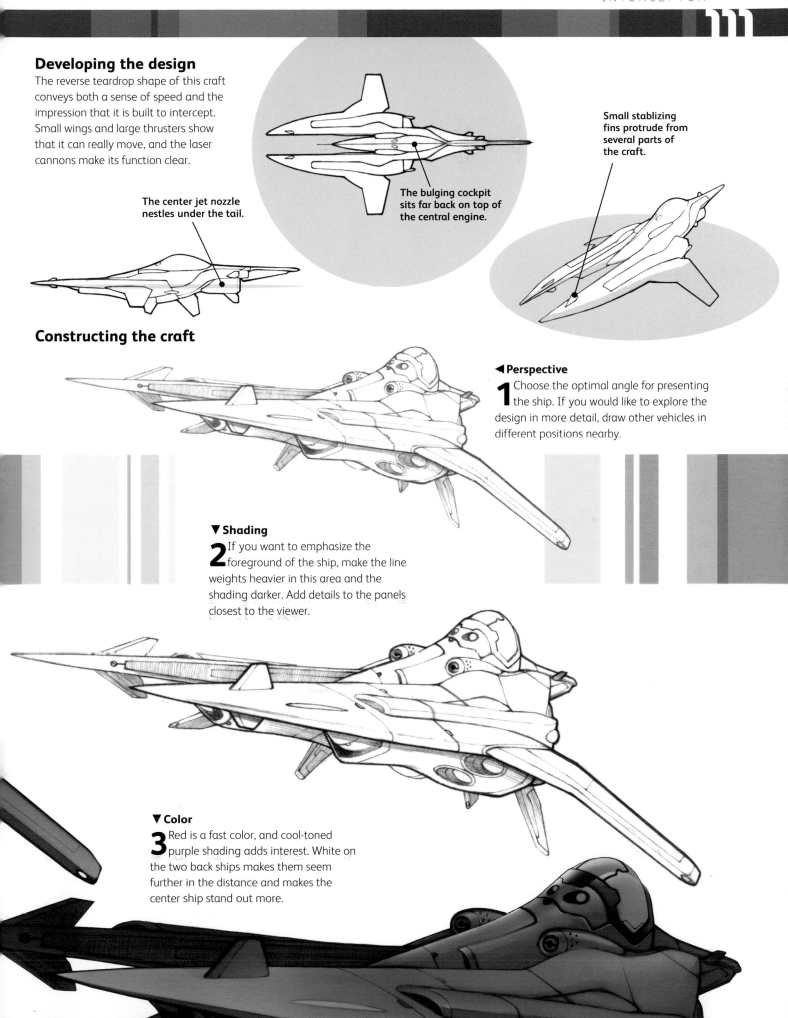

Developing the design

The reverse teardrop shape of this craft conveys both a sense of speed and the impression that it is built to intercept. Small wings and large thrusters show that it can really move, and the laser cannons make its function clear.

The center jet nozzle nestles under the tail.

The bulging cockpit sits far back on top of the central engine.

Small stablizing fins protrude from several parts of the craft.

Constructing the craft

◄ Perspective

1 Choose the optimal angle for presenting the ship. If you would like to explore the design in more detail, draw other vehicles in different positions nearby.

▼ Shading

2 If you want to emphasize the foreground of the ship, make the line weights heavier in this area and the shading darker. Add details to the panels closest to the viewer.

▼ Color

3 Red is a fast color, and cool-toned purple shading adds interest. White on the two back ships makes them seem further in the distance and makes the center ship stand out more.

ATTACK SHELL

This angle shows the craft's dominant line of action, which runs down the middle.

The rear canopy sweeps up and forward.

The wings tilt slightly upward and have a very angular curve.

From all angles
While texturally the craft is very complex, it can be easily and simply broken down into its basic structural shapes. Remember not to let twisted organic designs lose their structural basis even when a slightly formless design is intended.

Straddling the line between beautiful and disturbing, these intriguing vehicles hail from dark, mysterious, and unknown worlds, carrying bizarre entities at the helm. Formed using unearthly materials and construction processes, these alien craft employ a technology that defies our understanding of physics and engineering.

This bony protrusion has grown like a horn or tooth and is used for ramming other vehicles.

KEVIN CROSSLEY

ALIEN CRAFT

Developing ideas
Sharp and threatening, this craft takes an aggressive role, and this was to be apparent at first glance. Small glimpses of conventional mechanical elements peek through the organic elements showing a strange engineering process that mixes construction elements in a suitably alien manner.

► Large pipes and projections looked good but made the design appear a little too technologically unpolished for the intended feel of the craft.

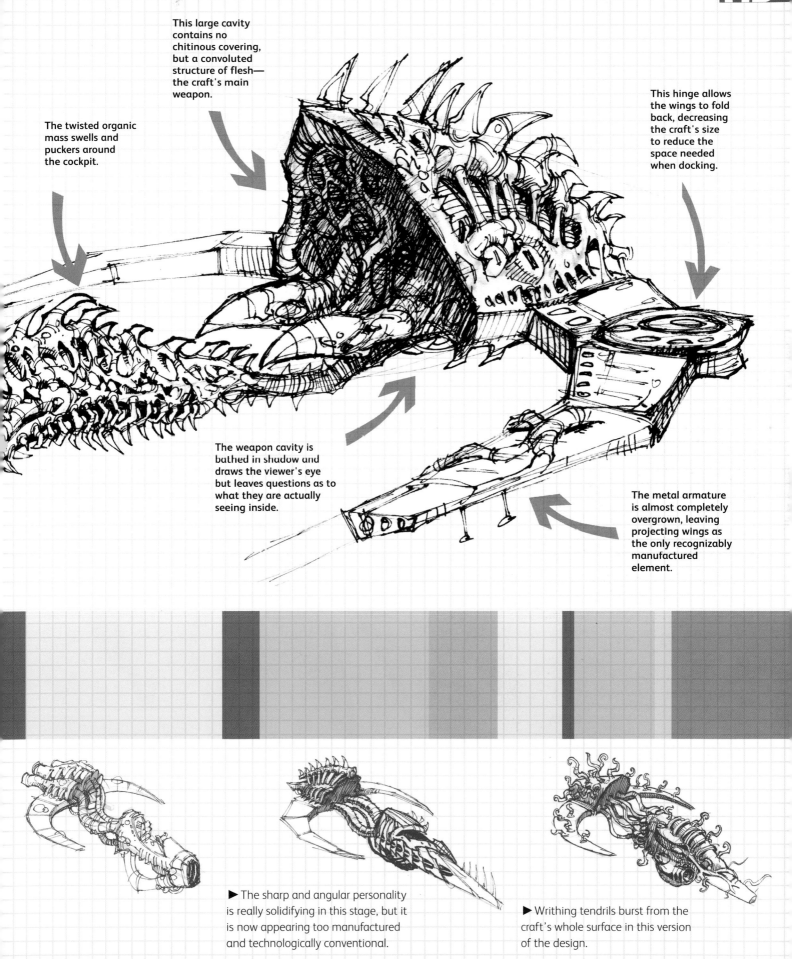

This large cavity contains no chitinous covering, but a convoluted structure of flesh—the craft's main weapon.

This hinge allows the wings to fold back, decreasing the craft's size to reduce the space needed when docking.

The twisted organic mass swells and puckers around the cockpit.

The weapon cavity is bathed in shadow and draws the viewer's eye but leaves questions as to what they are actually seeing inside.

The metal armature is almost completely overgrown, leaving projecting wings as the only recognizably manufactured element.

► The sharp and angular personality is really solidifying in this stage, but it is now appearing too manufactured and technologically conventional.

► Writhing tendrils burst from the craft's whole surface in this version of the design.

The first **combat-dedicated** craft to grace space with its presence, the Phyto-Assault Ship was developed by the Galactic Fair-Trading Association for dismantling **illegal** enemy space facilities. Its name denotes its initial and consistent use as a tool against colonial agricultural communities who actively **violate** or fail to comply with the Association's system of tariffs and trade regulations.

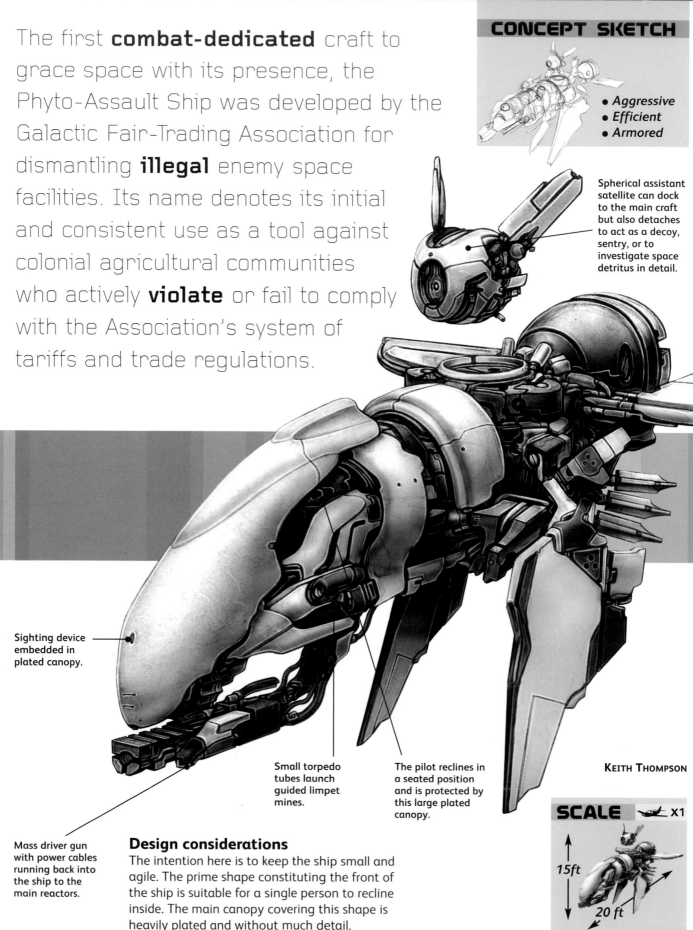

CONCEPT SKETCH

- *Aggressive*
- *Efficient*
- *Armored*

Spherical assistant satellite can dock to the main craft but also detaches to act as a decoy, sentry, or to investigate space detritus in detail.

Sighting device embedded in plated canopy.

Small torpedo tubes launch guided limpet mines.

The pilot reclines in a seated position and is protected by this large plated canopy.

KEITH THOMPSON

Mass driver gun with power cables running back into the ship to the main reactors.

Design considerations
The intention here is to keep the ship small and agile. The prime shape constituting the front of the ship is suitable for a single person to recline inside. The main canopy covering this shape is heavily plated and without much detail.

SCALE X1

15ft

20 ft

Developing the design

The structure of the ship is quite geometric despite its curved, flowing appearance in the finished version. The ship's bilateral symmetry helps the pilot direct the craft. The fins, or wings, protrude from the body of the craft, which has three main separations along its length.

The satellite is disconnected but floats above its circular docking bay on the ship.

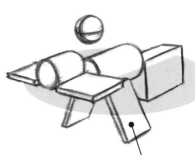

Each major body section is set lower than its predecessor, creating a gradual incline from front to rear.

The wings point downward from the ship.

Constructing the craft

▶ Linework

1 At the linework stage, the basic shapes and designs should begin to gel.

Although a jet-fighter appearance has been used as a vague basis for this design, there's no need for any aerodynamic concerns (unless the ship is intended to additionally function within an atmosphere).

▶ Shading

2 Use shading and highlighting to increase the readability of the image and bring the details forward so they can be visually explained to the viewer.

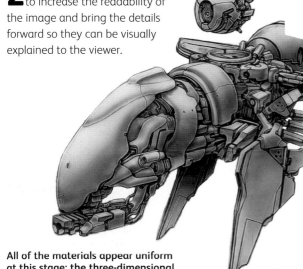

All of the materials appear uniform at this stage; the three-dimensional form of the entire structure is what's important right now.

▶ Coloring

3 Use the slightest hints of color variance and texturing to bring life to the surface of the spaceship without ruining its clean, metallic appearance. Small splashes of red LEDs and wiring add interest in the convoluted detail.

With the addition of color and bright reflections, different elements of the ship become more visually and conceptually separated.

Long ago, the Gaia Empire abandoned primitive metal machines for **organic** craft like this—a fusion of natural compounds that are light yet durable. The **aerodynamic** carapace is translucent, providing a wide field of view. The complex array of **antennae** receive eleven forms of sensory input so the craft can communicate with many species.

CONCEPT SKETCH

- *Organic and mechanical*
- *Streamlined*
- *Sophisticated technology*

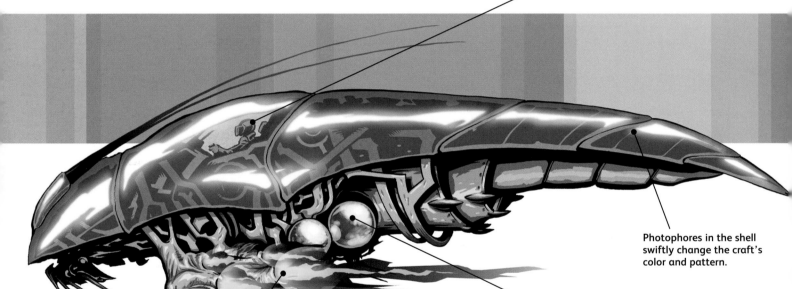

Main sensory organ is linked to the pilot telepathically.

Photophores in the shell swiftly change the craft's color and pattern.

Fuel spheres are packed with nutrients to be metabolised by the bio-engines.

DAVID WHITE

Secondary sensor array is used for external communication.

Bio-exhaust ports are located under the abdomen of the craft.

SCALE

✈ X1

15 ft

20 ft

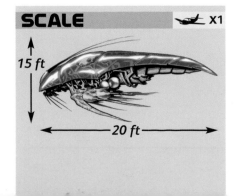

Design considerations

This is an "organic" craft and so needs to have natural surface textures. (It is based on insect exoskeletons, which often have shiny, translucent areas.) But the craft must also look constructed; the angular shapes that mesh under the carapace show this isn't just a giant space bug.

Developing the design

Even irregular organic shapes can be simplified. The craft's curvaceous and sleek profile is apparent even in the sharp-edged pieces here. The sets of spines radiate out symmetrically from the hull at different angles. The craft slants forward in motion, its nose presenting the lowest point other than the extended spines.

The top portion lies over the vehicle like a shell.

The tail ends in a thin point.

The pilot will be placed behind the front nose shape.

Constructing the craft

The visible internals under the canopy have lines that don't touch the edges of the overlaying panels.

▶ Linework

1 The best technique for creating alien designs is to contrast natural-looking curves with angular, mechanical shapes. Draw this initial artwork in a sketchbook at approximately 8 in. (20 cm) and then scan the drawing into a computer and resize it to about 15 in. (38 cm).

Take care with the delicate and sweeping lines of the extended sensor arrays.

▼ Inked drawing

2 Print out the drawing on paper 11 x 17 in. (27.5 x 42.5 cm). An image created at a larger size is much more detailed and sharp when printed smaller. Now trace the design onto smooth bristol board. To ink in the lines, use a No. 2 brush, which gives a varied line weight and so helps give a more organic feel.

Special effects such as haze and the bio-exhaust are added on top of this step.

▼ Coloring

3 Keep the basic colors simple until you are sure they are correct. First, add some flat colors and see how they look. Then, tint some of the lines to help control the complexity of the linework and guide the viewer's line of focus. Once you are happy with those aspects, add details and accent colors.

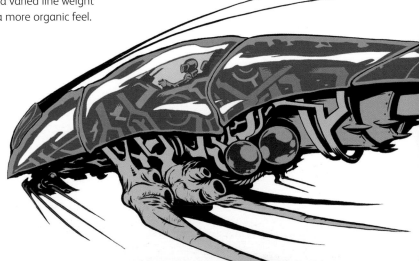

Former soldiers of wars against the Polyp Countries tell tales of seeing their comrades routed by **horrifying cavalrymen**, whose mounts galloped jerkily on **rickety stumps**. These steeds were once human, now twisted by the growth agents that flow throughout their vascular systems. Cavaliers who disgrace themselves in battle are forcibly injected with the polyp agents and transformed into new steeds, ridden by their now promoted squires.

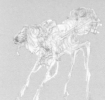

CONCEPT SKETCH

- *Grisly*
- *Infected*
- *Formerly human*

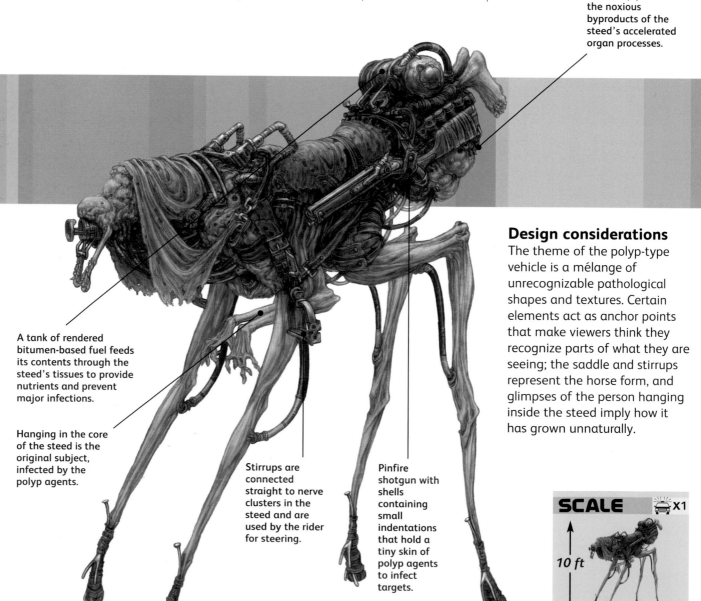

Exhaust pipes belch the noxious byproducts of the steed's accelerated organ processes.

A tank of rendered bitumen-based fuel feeds its contents through the steed's tissues to provide nutrients and prevent major infections.

Hanging in the core of the steed is the original subject, infected by the polyp agents.

Stirrups are connected straight to nerve clusters in the steed and are used by the rider for steering.

Pinfire shotgun with shells containing small indentations that hold a tiny skin of polyp agents to infect targets.

KEITH THOMPSON

Design considerations

The theme of the polyp-type vehicle is a mélange of unrecognizable pathological shapes and textures. Certain elements act as anchor points that make viewers think they recognize parts of what they are seeing; the saddle and stirrups represent the horse form, and glimpses of the person hanging inside the steed imply how it has grown unnaturally.

SCALE

🚗 X1

10 ft

← 7 ft →

Developing the design

Even when legs become this thin and elongated, they should still have an increased bulk of muscle where they join with the torso. The upper leg muscles are shown here as squashed spheres without a full width. They do not bulge out too far from the body.

The rear legs are splayed wider than the front legs.

The upper torso continues straight into the head with no discernible neck.

The stance is balanced and static because the steed is not depicted in the middle of movement.

Constructing the craft

▶ Linework

1 Loosen up on the linework here and use the texture of the pencil to do half the work for you. The roughness created by using a pencil at an angle on nicely textured paper is invaluable in depicting frayed and worn materials.

▼ Shading

2 This is a chance to really indulge in the texturing of the design. The skin alone puckers in a variety of patterns, and the ragtag collection of materials varies from dented, rusty metal to sheets of burlap and old leather.

The variety of textures has to be brought forth when shading.

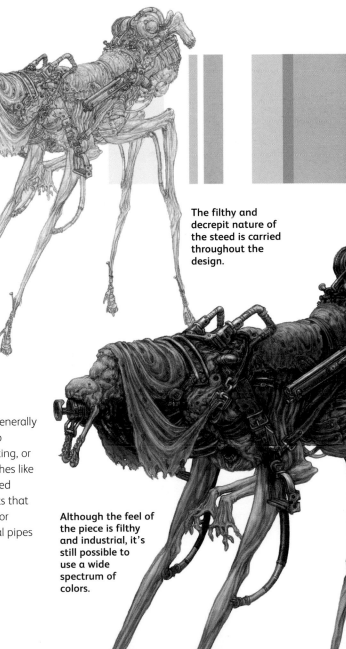

The filthy and decrepit nature of the steed is carried throughout the design.

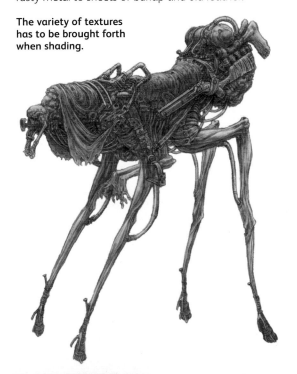

▶ Coloring

3 Subtly mix colors together over a generally brown or gray area to produce bruising, rusting, or staining effects. Touches like bruising should be used sparingly and on parts that make visual sense—for example, where metal pipes enter the skin.

Although the feel of the piece is filthy and industrial, it's still possible to use a wide spectrum of colors.

Those with enough **wealth** in the Piscine Empire often vacation on extended cruises aboard craft like the Luxury Nautiloid to enjoy **relaxing** tours of the territories. The Empire's **elite** citizens enjoy their own quarters, lavish dining halls, a huge theater, and verandahs offering excellent views of the surrounding ocean. There are also holds for their slaves.

Upper observation deck for those with eyes strong enough to look up at the light shining down from the water's surface.

The ship can move fore or aft and, if in danger, the tentacles retract and the surrounding plates close up.

Huge windows offer a commanding view of the seascape from the comfort of interior dining areas and lounges.

The shell is empty, and the protruding parts of the ship can retract into armored safety when needed.

KEITH THOMPSON

Extended, flared, muscular hydrostats are often used to pull surface craft down into the water for the amusement of the more spiteful tourists.

Design considerations
Its role as a luxury craft allows this design to be primarily decorative in appearance so that its functions and hydrodynamic qualities are relegated as secondary concerns.

SCALE X1

65 ft

100 ft

Developing the design

The focal point, the eye window, is placed in the middle where all the shapes converge. Viewed from the front, the craft is quite tall and thin. As visually convoluted as the final design is, it remains structurally simple.

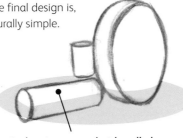

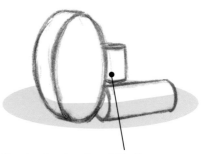

The plane of equilibrium shows how the craft balances, but it would never emerge this high from the water.

The tentacles stay somewhat bundled together for most of their length and fit nicely in a single cylinder.

The structural parts outside the shell should conceivably be able to retract back into the main cylinder.

Constructing the craft

▶ Linework

1 Use light hatching on the curves of the shell to aid in the development of the craft's form—this will carry through and still be subtly visible in the final piece.

The lines are fluid and organic, giving the viewer pause over whether this craft has been built or grown.

▶ Shading

2 Do not work too sharply with the shading or introduce strong contrasts, but remember that the craft should be lit by heavily diffused light traveling down through water.

The shading on the tentacles is carefully executed in order to really bring out their rounded form.

▶ Coloring

3 The luxury nature of the craft and its resemblance to an exotic sea creature present an opportunity to apply an indulgent, jeweled color scheme, playing off a multitude of hues against each other.

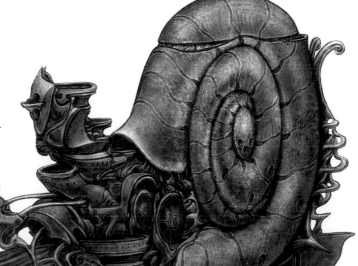

The use of several colors mixed together on the shell produces a mother-of-pearl-like effect.

The Nebula 1280 is the **workhorse** of all intergalactic fleets. Long journeys into deep space require more resources than can be carried by even the largest **starships**, which is where the Nebula comes into action. Each Nebula, piloted by a three-person crew, grazes **asteroid fields** and devours ore-rich rock and debris. The ore is then internally refined and returned to the fleet for use as raw construction materials.

DAVID WHITE

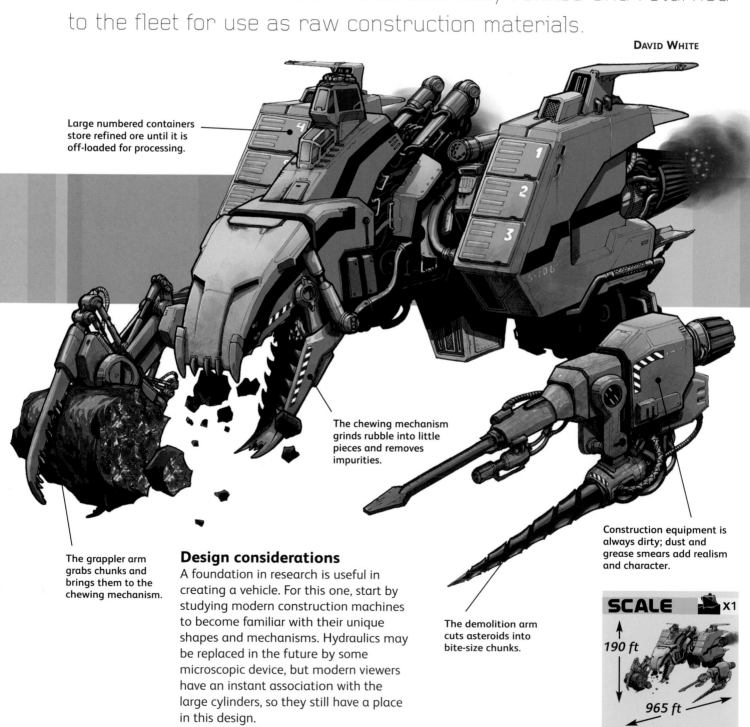

Large numbered containers store refined ore until it is off-loaded for processing.

The chewing mechanism grinds rubble into little pieces and removes impurities.

The grappler arm grabs chunks and brings them to the chewing mechanism.

Construction equipment is always dirty; dust and grease smears add realism and character.

The demolition arm cuts asteroids into bite-size chunks.

Design considerations

A foundation in research is useful in creating a vehicle. For this one, start by studying modern construction machines to become familiar with their unique shapes and mechanisms. Hydraulics may be replaced in the future by some microscopic device, but modern viewers have an instant association with the large cylinders, so they still have a place in this design.

SCALE ⬛X1

190 ft

965 ft

Developing the design

The Nebula's bulky, angular, clustered shapes and parts serve to establish the craft's resilient, potently powerful nature.

The animalistic structure, with the appearance of a bestial maw and grasping limbs, is key to the basic design.

The basic functions of the craft's two main limbs are apparent even in their shape.

Two large afterburner nozzles on the rear of the craft indicate the nature of the propelling system.

Constructing the craft

▶ Ink

1 Challenge yourself by drawing the design with ink. Skip any underdrawing and go right for the details.

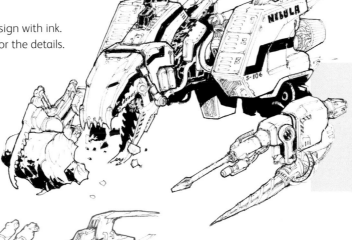

▲ Cleaning up

3 Use a modern comic book technique to clean up the sketch. Scan in the original sketch, changing the line color to light blue, and then print it to bristol board. You can ink directly over the blue lines, and it is easier and more accurate than using a light box. Your scanner will not see the blue lines, so you will end up with a clear image ready to color.

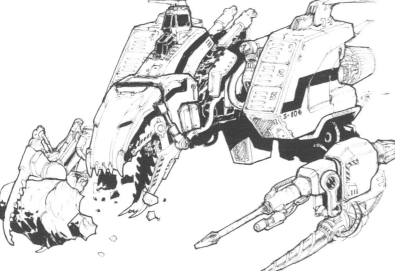

▲ Perspective

2 The end result of the ink sketch is still fairly rough, and some perspective is incorrect. See if you can fix the perspective without using drafting tools. They are useful, but they can slow you down and make your work look rigid. Add some detail; this Nebula has vents resembling eyes at the top of the chewing mechanism to impart a tough, mean attitude.

Reconnaissance wings of the Polyp People's Militia survey their territories from the baskets of specially cultured men-o'-war. These living organisms, used as a mode of high-atmosphere conveyance, have **survived** desperate encounters with the enemy thanks to their ability to **heal** their own injuries.

This highly retentive membrane swells with the buoyant bacterial gases inside that carry the craft aloft.

This eye is no longer connected to an occipital nerve and merely spasms, unseeing.

KEITH THOMPSON

Air rudder aids in steering the balloon; adjusting it also pulls on the polyp's vestigial ischium, helping to convey the pilot's desired direction.

Pivoting belt-fed enamel rifle for air-to-air engagement.

Gunner's bubble with quad enamel rifles for air-to-surface fire.

Design considerations
Every element in this design visually hangs from the balloon part of the vehicle. Although the balloon could conceivably contain gasses so much lighter than air that it could be of any size, it should still be the largest part of the design.

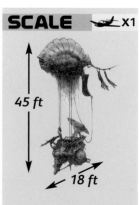

SCALE ✈ X1

45 ft

18 ft

Developing the design

The basket should hang centered from the balloon regardless of the angle of view. Keep the basket reasonably far from the balloon so air turbulence does not rock the occupants loose. Unlike a hot-air balloon, this vehicle has a defined alignment for powered movement (the direction the eye faces).

From this angle it is clear that the balloon is not completely round but more ovoid.

Remember that this sphere is hollow for an occupant, and should not make the basket imbalanced.

Occupants sit inside the basket opening that coincides with this squat cylinder.

Constructing the craft

▼ Linework

1 Keep the linework sinuous and flowing, remembering that all the elements, even the railing and partial canopy, have grown out of this engineered creature.

▼ Shading

2 Lightly shade the air- or gas-filled parts, such as the balloon and gun dome, remembering that diffused light can travel partially through these strong but thin membranes.

▼ Coloring

3 A wildly mixing series of rosy, organic hues is reminiscent of jellyfish and sea polyps. Conceptually speaking, pink is one of the hardest hues to see in the sky and so camouflages the balloon rather well.

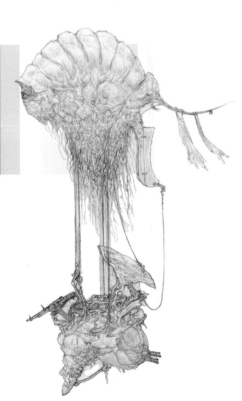

Puckered and organically gnarled, the linework should be gestural.

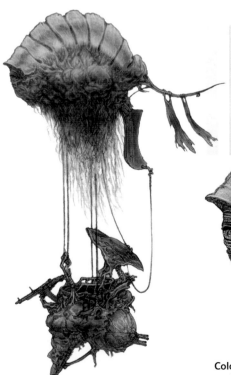

A full volume on the balloon must be conveyed through shading to ensure that the viewer imagines its buoyancy.

Colored details—capillaries and flushing—help convey that this vehicle is living.

INDEX

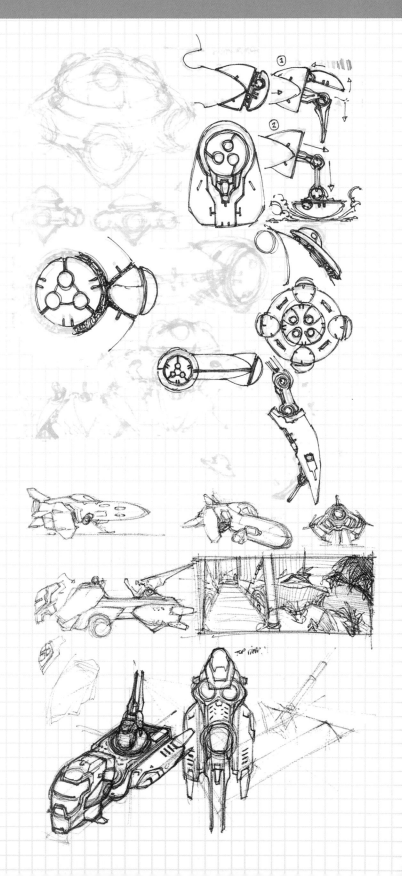

CREDITS

Quarto would like to thank and acknowledge the following artists for supplying work reproduced in this book:

Key: t = top, b = bottom, l = left, r = right, c = center

Thierry Doizon www.barontieri.com
8b, 10r, 11tr, 22bl, 23t
Yan Klaiman www.toltec.gfxartist.com/artworks
11tl, 25 (stitched sails)
Corlen Kruger www.corlen.adreniware.com
1, 2, 3, 5, 6b, 8t, 21c, 22cr, 23c, 23b, 36, 127
Damien Rochford www.damienrochford.co.uk
21b
Tek! www.poompee.be
10l
Xen www.xenusion.com
11bl
See also artist credits on pages 4 and 5.

Quarto would also like to acknowledge the following:

Douglas P. Wilson; Frank Lane Picture Agency/CORBIS
20tc
Carl & Ann Purcell/CORBIS
29br
Kjeld Duits www.ikjeld.com
9tl
EA
9bc
www.hovpod.com
29bl
Dreamworks/Warner Bros/The Kobal Collection
9cr
MGM/EON/The Kobal Collection/Maidment, Jay
9tr
MallCarts.com, Inc.
9cl, 9bl
Treasure Inc.
9br